Sculpture in the Kingdom of Quito

Sculpture in the Kingdom of Quito

Gabrielle G. Palmer

University of New Mexico Press

Albuquerque

Library of Congress Cataloging-in-Publication Data

Palmer, Gabrielle G., 1938–
 Sculpture in the Kingdom of Quito.

 Bibliography: p.
 Includes index.
 1. Sculpture, Ecuadorian—Ecuador—Quito. 2. Sculpture, Colonial—Ecuador—Quito. 3. Wood-carving, Colonial—
Ecuador—Quito. 4. Wood-carving—Ecuador—Quito. I. Title.
NB1255.E2P35 1987 730'.9866'13 86-24959
ISBN 0-8263-0930-5

To my mother

Contents

PART II

Illustrations

Figures

Plates

Acknowledgments

In addition to recognizing my indebtedness to the Samuel H. Kress Foundation and to my professors and advisors in the Art Department and the Latin American Center at the University of New Mexico, I would like to express my thanks to the many kind Ecuadorians without whose help this book would not have been possible.

Among the ecclesiastical authorities, I would like to acknowledge the assistance of his Excellency Pablo Cardinal Muñoz Vega; Msgr. Giovanni Ferrofino, Papal Nuncio; Msgr. Alberto Luna, auxiliary bishop to the Archdiocese of Quito; Msgr. Angel Gabriel Pérez of the Metropolitan Cathedral; Fr. Oswaldo Carrera, S.J.; Fr. José María Gallardo, C.P.M.; Fr. Julio Fernando Pozo, O.F.M.; and, of course, Fr. José María Vargas, O.P. To the Mothers Superior of the convents of Santa Catalina, Santa Clara, El Carmen de San José, and El Carmen de la Santíssima Trinidad, my sincere thanks for allowing me to study their private collections of art.

To Arq. Hernán Crespo Toral, director of the Museums of the Banco Central del Ecuador, to Sr. Vicente Mena, director of the Casa de la Cultura, to Sr. Carlos Rodríguez, director of the Museum of Arte Colonial, and to Fr. José María Vargas, director of the Jacinto Jijón y Caamaño Museum, my thanks for their cooperation in allowing me to study and photograph their collections.

I am particularly grateful for the assistance of the Instituto de Patrimonio Cultural del Ecuador and, above all, for the generous cooperation of Lic. Ximena Escudero de

Terán, chief of the Department of Inventory, as well as to Sra. Cecilia Aranda de Ortiz and to Srta. María del Carmen Molestina.

In Spain, I was indebted to various members of the Instituto "Diego Velásquez" of the Consejo Superior de Investigaciones Científicas, of the Instituto de Cultura Hispánica, and to various professors of the departments of Hispanic Art at the Universities of Madrid and Sevilla for their counsel.

I also owe a real debt of gratitude to Mrs. Constance Darkey of Santa Fe, New Mexico, who spent so many hours helping to edit and revise this manuscript, to Srta. Victoria Cabrera who helped me in innumerable ways, and to Mr. George Bailey for his personal assistance.

Acknowledgments

Preface

The old colonial section of Quito, capital of Ecuador, is a vast storehouse of Spanish colonial treasures—dazzling churches, innumerable paintings, gold and silver ornaments, and altar screens, as well as the carved wooden statues with which this study is concerned.

Spanish colonial art spans a three-hundred-year period. Examples are everywhere apparent in South and Central America, in the Philippines, and in the Southwest of the United States. The art of this period was almost exclusively at the service of the Catholic Church. One of its most important manifestations, both from a religious and an aesthetic standpoint, were those cult images carved in wood and realistically painted. Many of these can still be found in Quito's churches and convents and, more recently, in modern museums. However, to date, this art has received relatively little attention or study. In Quito, the first general survey of Quitenian colonial sculpture, *La historia de la escultura,* was written by José Gabriél Navarro in 1929. In recent years, Fr. José María Vargas, O.P., has examined the Quitenian archives in depth and made his findings available in numerous publications which provide indispensable sources for the study of Quitenian colonial art.

I first went to Ecuador in 1969, under the sponsorship of the Art Department of the University of New Mexico, to write a general survey of Quitenian art. In Quito I was extraordinarily fortunate to have been given special permission to view the art of the cloistered convents. I emerged from the whole experience fascinated by colonial art and

by colonial sculpture in particular. This was the subject to which I subsequently dedicated a period of study in Spain as well as in South America. Such study is not without its hazards since documentary references to specific statues are scarce. Moreover, these sculptures are present in such profusion and in such chronological disorder that the work of identification is slow and arduous. Thus a scholar is usually forced to employ a method of visual analysis to establish provenance and chronology.

It had long been known that some of these images were Spanish in origin, while others had been executed in Quito by colonial artists. I thought it was necessary to distinguish between them and to establish a general chronology for the whole colonial period. The results of my research were presented in a doctoral dissertation, "The Sources and Origins of Quitenian Colonial Sculpture (1534–1809)." Such academic documents, however, reach only a limited audience, and I was convinced that a book on the subject dedicated to a more general audience, to the intelligent and curious reader, was warranted. Such a book would not only serve to introduce the specialized subject of Quitenian colonial sculpture, but might encourage a broader appreciation of the whole field of colonial art.

I was able to undertake this project when, through the kind offices of its vice-president, Miss Mary M. Davis, the Samuel H. Kress Foundation of New York in 1980 awarded me a grant. This allowed me to return to Quito, to review my original research, and to oversee the taking of the photographs which illustrate this book. The illustrations are in no way subordinate to the text but are its very core, for one is increasingly aware that the richness and complexity of art are far greater than is the ability of language to explain or describe it. Art must be allowed to speak for itself, to reveal to the discerning eye the patterns intrinsic to its own nature.

The selection of subject—carved wooden statuary based on the human figure—was a deliberate one. Carefully defined in its scope, this study forced a deeper and more focused concentration than could be achieved in a less restricted field of study, and it yielded unexpected results when seen from the standpoint of psychology.

The material presented in this book divides itself naturally into three sections. Part I deals with the sixteenth and seventeenth centuries, a period when the greatest number of statues were imported to Quito from southern Spain. Part II discusses the school of indigenous Quitenian colonial sculpture to which Spanish statuary gave rise in the

eighteenth and in the early nineteenth centuries. Chapter 1 serves as a general introduction to the four which follow. It deals briefly with the Spanish conquest of the Kingdom of Quito, with Quito's pre-Columbian history, and with her first years as a Spanish colony and the early phase of construction of her principal religious buildings. Chapter 2 introduces the subject of religious polychrome wood sculpture during Spain's golden age of sculpture (1580–1680). Chapters 3, 4, and 5 are dedicated to a chronological enumeration of the principal works of Spanish sculpture exported to Quito from Andalucian workshops. Chapter 6 provides a general introduction to the nature of Quitenian society in the eighteenth century—its isolation, the role of the urban environment, and the importance of the mestizo, particularly of the mestizo artist. Chapter 7 serves as an introduction to the techniques, subjects, and scope of Quitenian colonial sculpture. Chapter 8 describes the Quitenian Baroque, Chapter 9 the Quitenian Rococo.

The conclusion presents an original theory. In the course of my studies I became increasingly dissatisfied with a purely historic or stylistic approach to the history of art. Prompted by a growing conviction that all too often art is studied principally as a concomitant to history, and confronted with the inability of such an approach to answer some of the questions which presented themselves, I expanded my reading to include Jungian psychology and comparative mythology. There I found not only a wealth of challenging new ideas, but an address to the deeper psychological level for which I had been searching. My philosophical premise suggests that Quitenian colonial sculpture should not be viewed solely as a derivation based in European prototypes, for it exhibited a style and originality of its own. More than that, however, the art of the Baroque, in Quito as in the rest of the Spanish colonies, was not a reaction but was in itself an authentic and original act of creation. I believe that this artistic creativity both anticipated and provided the psychological foundation for the revolutions which brought freedom to the colonies of Spanish America and a close to the whole colonial era.

1 Historical Background

During the joint reign of the Catholic monarchs Ferdinand (1474–1516) and Isabella (1474–1504), Spain was united and first emerged as a European power, and it was also during their rule that America was discovered. They were succeeded by Charles V (1516–56), who with the subsequent discovery, conquest, and incorporation of vast lands of Spanish America, became the ruler of one of the largest and most important empires in world history. His son and successor, Philip II (1556–98), consolidated this absolutist monarchy, reinforced the political and ideological alliance with the Catholic Church, and further developed the authoritarian and monopolistic policies which characterized the Hapsburg rule.

After the death of Philip II, Spain was ruled by a succession of increasingly inept Hapsburg kings, of whom Charles II (1665–1700) was the last. During this decade, the country suffered from poor administration, the decay of its economy, and a steady loss of political prestige. Continual wars with other European powers drained its energies and diverted its attention from its overseas colonies. Blockades interrupted colonial trade, and its bureaucratic power over the colonies gradually waned. In the last decade of the seventeenth century, Austria and France plotted to gain the Spanish throne. The French King Louis XIV managed to establish his nephew, Philip of Anjou, as Philip V, the new king of Spain, and thus inaugurated the rule of the Bourbon dynasty.

During the eighteenth century, Spain was to enjoy a rejuvenation. Allied to the courts of both Italy and France, she was increasingly receptive to the currents of modern and more liberal European thought. All of the forces for renewal culminated in the enlightened rule of Charles III (1759–88), under whom Spain again prospered. Governmental policies included a reorganization of the bureaucracy, legal reforms, urban renewal, liberalization of guilds, freedom of trade, and a separation of the secular government from its former close ties to religious institutions and affairs. This spirit of reform and the specific measures taken by the Spanish government had a decisive and beneficial effect on the life of the colonies, an effect that was particularly apparent in the last quarter of the century. It was left to Charles IV (1788–1808) and Ferdinand VII (1808) to preside over the dissolution of the colonial empire, for, one by one in the early nineteenth century, the colonies of Spanish America won independence from the country which had ruled them for almost three hundred years.

Figure 1

One of the areas conquered by the Spaniards was the ancient Inca capital of Quito which, including its surrounding area, remained under Spanish rule for almost three hundred years as the Audiencia or Kingdom of Quito. The name *Quito* is derived from the Quitus, one of the original tribes to inhabit the area. Conquered first by the Caras, then by the Shyries, both invaders from the coast, the entire territory fell to the Inca Huaina Capac around the mid-fifteenth century. The Inca empire was then at its height, and its territory stretched from present-day Chile to Colombia. Cuzco served as one of its capitals, Quito the other.

In 1525, the Spaniards, led by Francisco Pizarro, landed on the shores of Peru. Soon thereafter Huaina Capac died, leaving his kingdom to be divided between his two sons, Huascar and Atahualpa. In the jealous fratricidal warfare which ensued, Atahualpa emerged the victor. However, by then the Inca power had been fatally compromised, and Atahualpa was in turn vanquished by the invading Spanish forces. In 1533, Sebastián de Benalcázar, one of Pizarro's lieutenants, marched northward from Peru to conquer the Kingdom of Quito. After a series of skirmishes, Benalcázar engaged one of the last Inca rulers in a pitched battle in which two hundred armed and mounted Spaniards defeated twelve thousand Indians, aided by a providential eruption of a nearby volcano, Cotopaxi. Soon thereafter, Benalcázar marched on Quito and took possession of its territory in the name of the Spanish Crown.

Chapter One

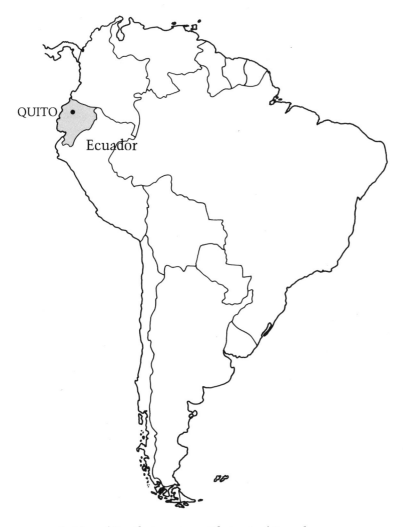

QUITO

Ecuador

1. *Map of South America with inset of Ecuador*

The town of San Francisco de Quito was established in 1534, and granted a royal charter in 1541. Four years later it was designated as the seat of an archbishopric and in 1563 named capital of the Audiencia under the final authority of the viceroy of Peru. An audiencia was the administrative and judicial body which governed one of the large subordinate areas of the Spanish colonial empire. Headed by a governor general, the territory was in effect ruled as if it were a virtual kingdom.

The years following the conquest were characterized by considerable political instability. By the last quarter of the sixteenth century, however, the process of colonization was well under way, and construction of the city had begun. During the seventeenth century, Quito became an important religious, administrative, and judicial center. In the eighteenth century it emerged as a distinguished cultural and artistic one as well. The city grew in size until it was exceeded only by Lima in importance.

Toward the end of the eighteenth century, the liberal philosophical and political ideas of the French Encyclopedists and the examples of the American and French revolutions began to influence the climate of thought in the colonies. Causes of the growing dissatisfaction with the colonial administration were clearly stated by Jorge Juan and Antonio de Ulloa, secret agents for King Philip V, who wrote what has been described as

a devastating account of the evils of the colonial regime including the venality of officialdom, the tyranny of the local magistrates, the heartless exploitation of the local Indian population, the depravity of the clergy and the abiding antipathy of the American-born Spaniard and the European Spaniard for each other.[1]

Unrest, fostered by rebellious creole and mestizo elements, culminated in open rebellion as the movement for independence gathered momentum. The final battle against the Spanish was won in 1809. At first, part of an alliance called Gran Colombia, Ecuador declared a separate independence in 1830, and the modern country we know today was born.

Anyone who visits Quito cannot fail to be impressed by its extraordinary natural setting and by the richness of the culture which grew up in the Spanish colonial era. Art historians must, of course, view the art they study with a certain detachment and objectivity. Some, however, find meaning in their work only if they are also caught up in an emotional response to the objects they study and to their surroundings.

The topography of Ecuador comprises two tropical zones—to the west that of the Pacific shore, to the east the wilder reaches of the Amazon Basin. Between them lies the Andean cordillera from which rise some of the highest volcanic peaks in South America. It has been called the roof of the world—*el techo del mundo*. Chimborazo's frosty summit rises over 20,000 feet, while others nearby almost as high bear equally euphonious names—Tunguragua, Cotopaxi, Cayambe, and Sangay. The impression is of a vast, untenanted space poised in an equally vast and fathomless silence. Between these two geographical extremes lies a variety of terrain. The *páramo*, a moor-like expanse, stretches from the edge of the snow down to timberline. Composed of spongy hillocks starred with a million tiny flowers, it is laced with rivulets whose waters are so cold and clear that they are practically invisible. Roving herds of wild horses crop its low vegetation, and occasional bands of sheep move like ghosts through its freezing mists. Below the *páramo* lie heavily forested slopes mingled with parcels of cultivated land. Some of these steep slopes plunge into even steeper river gorges. Others form more gentle gradients which broaden out into fertile valleys. In one of these lovely interandean valleys, at the breathtaking altitude of 9,300 feet, lies Quito, once the center of the Kingdom of Quito and now capital of the modern country of Ecuador.

Quito sits almost astride the equator which gives the country its name. Here the length of the days varies little in the course of the year, and the seasons are not sharply delineated, though, some say, the four seasons can often be experienced in the course of a single day. The morning, bright and fresh as spring, can by noon turn heavy under a hot summer sun. By afternoon, the day's autumn, long tendrils of mist gather and glide down the steep face of the surrounding hills. Occasionally storm clouds gather darkly and release sudden deafening torrents of rain and hail. In the ensuing calm comes a piercing winter-like cold.

Quito is divided between the old colonial section, the *casco colonial*, and the modern town which lies to its north. The ancient whitewashed buildings and the fluted tile roofs of the old town spill down the lower slopes of Mt. Pichincha, the dormant volcano which looms high above the town. Domes and bell towers mark the presence of the numerous churches and convents which are found in nearly every block at the center of the town. The great entrances are framed in shadows; within, their soaring vaulted spaces are resonant with the sound of murmured prayer and their

gilded altars seem to flicker in the dim half-light of votive candles.

Although the churches are always busy, the attached cloisters respond to a quieter rhythm. In the nuns' convents an even deeper calm pervades. Their ancient walls guard vows of silence and abnegation, isolating their reverent life from the world's bewildering temptations. Graceful arcaded galleries reflect each other across neat geometric gardens, enclosing a daily patient round of prayer whose murmured recapitulation echoes a timeless rise and fall, the beat of life itself, the slow sound of its heart. From within this ardent Catholic faith, with its special Spanish intensity and proselytizing fervor, Quitenian colonial art was born. In these crowded churches and silent private cloisters, the vast majority of Quitenian colonial art is found. In this context of pervasive religious life and of the historic past, the art of the colonial period should be understood.

Side by side with the Spanish conquistadores and early settlers came the priests of the various monastic orders—the Franciscans, the Augustinians, the Dominicans, the Mercedarians, and the Jesuits—who were to establish the religious life of the colony. Given lands by the Crown, they set to work in Quito as soon as possible to build their churches and convents. The first buildings were crude ones built of adobe. Most were replaced later by sturdier structures of quarried rock. Building was slow due to the chronic lack of funds and to the scarcity of competent professionals, and completion of a building often took many years. Although some construction was begun as early as the sixteenth century, most major construction was completed during the seventeenth and, to a lesser degree, in the eighteenth century. Today, Quito can claim some of the most magnificent churches in South America. The church of San Francisco stands as one of the principal monuments to the Renaissance style, as La Compañía, the Jesuit church, exemplifies the Baroque. The accompanying diagram of downtown colonial Quito designates the relative position of each of her principal churches; a prodigious number of extraordinary churches are concentrated in a small area.

Figure 2

The Franciscans were the first order to establish their monastery, for soon after the conquest they were given title to the lands from which would eventually rise a large complex of buildings—three churches, four cloisters, a college, orchards, and gardens. Construction of the first primitive buildings began under the vigorous direction of the most famous of the early fathers, Fray Jodocko Ricke. As early

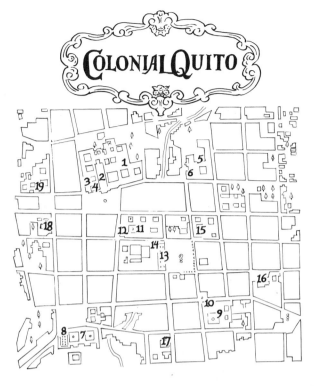

COLONIAL QUITO

1. CONVENT of SAN FRANCISCO
2. CHURCH of SAN FRANCISCO
3. CHURCH of CANTUÑA
4. CHURCH of SAN BONAVENTURA
5. CONVENT of LA MERCED
6. CHURCH of LA MERCED
7. CONVENT of SANTO DOMINGO
8. CHURCH of SANTO DOMINGO
9. CONVENT of SAN AGUSTIN
10. CHURCH of SAN AGUSTIN

11. CONVENT of LA COMPANIA
12. CHURCH of LA COMPANIA
13. THE CATHEDRAL
14. THE SAGRARIO
15. LA CONCEPCION
16. CARMEN MODERNO
17. SANTA CATALINA
18. CARMEN ANTIQUO
19. SANTA CLARA

FIG. 2

as 1573, a contemporary chronicler could write that San Francisco was a well-built stone church and that the convent was under construction. By the mid-seventeenth century, the main church and several of the cloisters had been completed, and by the end of the century, the construction of the contiguous church of Cantuña was in progress. The retreat of San Diego, at some distance from the convent, was built around 1625. Though recurrent earthquakes did much to damage the original structure, which was subsequently modified and rebuilt, San Francisco stands today as one of the principal artistic monuments in Spanish America and houses the single most significant collection of imported Spanish statues.

Other churches soon followed. In 1580, the Spanish

architect Francisco Becerra drew plans for the convent and church of the Dominican Order. Completed by the mid-seventeenth century, the church was decorated with a painted and gilded ceiling and had a richly adorned sacristy, carved choir stalls, and many fine paintings and statues. The same Becerra designed the church and convent of San Augustín, which also was completed by mid-century. At that time the church had a number of beautiful altars and rich decorations. The Order of Mercedarians, among the first to arrive in Quito, had been provided with land of their own. By mid-century a solid masonry church had been completed, only to be demolished in the earthquake of 1698. The present church which replaced it was finished around the middle of the eighteenth century. Plans for the present Jesuit church were drawn and construction directed by the Neapolitan architect Fray Marcos Guerra, who arrived in Quito in 1636. The Baroque facade of the church, one of the most splendid in Spanish America, was begun in 1722 and completed in 1765. In 1535, only a humble building occupied the present site of the cathedral. A more permanent construction was begun in 1555 and completed in 1563. Severely damaged in the 1660 earthquake, it was renovated and enlarged in 1674–78. In the following century, it was again badly damaged, again rebuilt. Much of the interior decoration dates from the nineteenth century. The adjoining sacrarium, el Sagrario, was established in 1630 and completed in the last half of the seventeenth century. Its handsome facade, begun in 1669, was completed in 1706.

In the last part of the sixteenth century and during the seventeenth century, a number of nunneries were also established. Members of the convent of the Immaculate Conception were the first to settle in Quito in 1577. By 1625, their cloister and church had been constructed, and by mid-century the church was decorated with an elaborate main altar, coffered wooden ceilings, and an imposing collection of paintings and sculptures. Another Franciscan Order, the Clares, was established in 1596; their church was built under the direction of Fray Antonio Rodríguez around 1567.

A community of Dominican nuns arrived in Quito in 1592. Their convent cannot today claim the same artistic riches as some of the other convents, but its thick old walls and lovely garden are among the most evocative of the Quitenian past. Two Carmelite convents were established in Quito in colonial times. The oldest, the convent of El Carmen de San José, popularly known as Carmen Alto or Carmen Antiguo, was founded in 1653 by three nuns from

Lima. The present church and convent were designed and the construction directed by the Jesuit architect Marcos Guerra between 1656 and 1661. The second order of Carmelite nuns arrived in Quito in the last years of the seventeenth century after their convent in the town of Latacunga had been totally destroyed in the 1698 earthquake. First taking refuge with the nuns of Carmen Antiguo, they were eventually able, in the eighteenth century, to construct their present quarters, known as El Carmen de la Santíssima Trinidad, or colloquially as Carmen Bajo. Parish churches were built in outlying districts of the town during this same period. In most cases the original structures have been much modified and their original decorations have disappeared.

As these religious edifices were built, the work of decorating their interiors was undertaken. Wooden altar screens or retablos, their designs taken from European engravings, were carved and put into place. The high altar or *altar mayor*, placed at the blind end of the sanctuary, was the most impressive. Other retablos later were placed at the ends of the arms of the transept and, under the exuberant influence of the Baroque, all along the walls of the nave as well. Divided horizontally into tiers and vertically into niches, the sixteenth-century classical retablos were composed of shallow recesses separated by simple pilasters and decorated with restrained motifs. In the Baroque age they evolved into a towering three-dimensional structure and the niches, often flanked by heavy solomonic columns, were significantly enlarged.

The niches of the earliest retablos had been decorated with paintings. In time statuary was placed in these niches. The first of these images were not Quitenian but exported to the colony from Spain from some of the most famous and representative workshops of Andalucia. The story of these exports, their presence in Quito, and the school of indigenous Quitenian sculpture to which they eventually gave rise provides the subject of the following chapters. The statues selected for this study will be viewed in uncharacteristic isolation, as individual works of art. In fact, they belong in a religious setting in which they function as revered icons.

2 Spanish Sculpture

In the sixteenth century, during the Hapsburg rule, the towns of both Sevilla and Granada grew as established centers of art. Granada, one of the most important cities during the Moorish occupation of southern Spain, enjoyed a revival during the rule of Charles V, and soon thereafter Sevilla emerged as an important bureaucratic center.

During the Hapsburg reign, the Council of the Indies and other governmental agencies charged with the management of the American colonies had been established in the town of Sevilla. Throughout most of the seventeenth century Sevilla continued to serve as principal link between Spain and her overseas empire in administrative, judicial, and commercial matters. The city continued to grow steadily in wealth and importance until, under the vacillating management of the last of the Hapsburg "do-nothing" kings, it lost much of its power and prestige. In the eighteenth century it was largely bypassed due to the trade policies of the Bourbon monarchy. At its height, Sevilla was, however, one of the most brilliant cities in Spain. Trade with the colonies was an important and lucrative affair, and, as wealth from the Indies poured in, money was lavished on the arts, and a brilliant artistic milieu flourished. One of the most distinguished manifestations was the art of religious polychrome wood statuary; this art form reached its apogee from 1580 to 1680, a period known as Spain's golden age of sculpture. During this time, sculptures exported from both Sevilla's and Granada's principal workshops provided

the Spanish colonies with some of their finest carved Christian images.

In northern Spain, principally in Valladolid, a new type of religious polychrome wood sculpture, based on innovations in both style and technique, first made its appearance. A number of sculptors trained in these northern centers migrated to Andalucia in the late sixteenth century and established centers in both Granada and Sevilla. Though these towns were located at some distance from each other, their artists enjoyed a continuous exchange, often collaborating with one another, borrowing motifs, and sharing ideas. Each center, however, had a regional flavor. The art of Sevilla tended toward classicism and restraint, while that of Granada emphasized color and decorative values.

During the period 1580–1680 the art of Spanish sculpture underwent a series of stylistic changes. These styles had all originated in Italy and spread from there to other centers in Europe and eventually to the Americas. In each locality the chronology was different; in each the styles were somewhat modified to conform to the local culture. In very general terms, the Renaissance style reigned from the fifteenth to mid-seventeenth century, closely followed by the Baroque, which prevailed until the end of the eighteenth. Mannerism and Realism provided transitional elements in the sixteenth and seventeenth centuries. In fact, neither stylistic characteristics nor chronologies can be rigidly fixed since these various styles overlap and intermingle to form an organic whole which flows, by imperceptible degrees, from one stage to the next.

Renaissance classicism drew upon the artistic forms and precepts of Graeco-Roman antiquity for inspiration and grafted them onto the theology and mythology of Christianity. Mannerism was the beginning of a challenge to the increasingly authoritarian conviction that all fundamental moral and aesthetic canons had been discovered and, in a definitive sense, codified. In the sixteenth century, the Protestant Reformation had attacked the Catholic Church for its insistence on ritual hierarchy, form, and outward pomp to the neglect of personal conscience. Mannerism provided a parallel in art. The self-assured forms of the Renaissance gave way to uneasy and ambiguous distortions of space and perspective. Calmness was replaced by a new restlessness and dramatic tension. The Protestants had emphasized a return to inner content and focused on individual behavior and its relation to salvation. Mannerism carried with it a suggestion of introspection and a promise of freer and more imaginative rhythms, ideas which were to find

their fulfillment in Realism and in the Baroque. The role of Mannerism as a transitional style was of greater significance in Italy than in Spain. In Andalucian sculpture Realism served a similar transitional function, which provided the bridge from the Renaissance to the Baroque. Considered by some as a distinct artistic style, Realism revealed a gradual detachment from formal abstraction and a movement toward the representation of the human figure which, though idealized, was close to individual human likeness. This gradual turn toward tangible reality manifests itself in the Baroque as an ever more explicit naturalism. The Baroque represents the pivotal moment when the collective becomes grounded in the individual, when God descends into man. The concept of individuality is then expressed both in man's relationship to his own inner world and subsequently in a rediscovered interest in the surrounding physical world.

The Catholics had answered the Protestant Reformation with the Council of Trent (1545–47, 1551–52, 1562–63). They sought to establish reforms of their own, to reassert and to deepen their traditional values. As a result the Catholic world awoke to a new period of evangelical and moral fervor. In contrast to the austerity of the Protestants, the Catholics chose to reemphasize the cult of saints and the visual arts. In the Baroque, the Roman Catholic Church found an art that addressed all people. This new artistic style employed every available means to engage the senses and the emotions and was admirably suited to the conversion of the masses of the New World. In the transition from grave Renaissance classicism to Baroque vitality in Spanish sculpture, the closed silhouette gave way to an open one, and aloof, hieratic images were replaced with warm, personal characterizations; simplicity and clarity yielded to organic profusion and to expression of physical vigor and emotional exuberance.

Though much of early Spanish sculpture had concentrated on panels carved in high relief and composed of many figures, the individual freestanding image provided its eventual focus. Spanish sculpture was almost exclusively religious in theme and included lifelike representations of the divine, semidivine, and human figures central to Catholic belief and worship. These included God the Father (often shown "leaning out from Heaven"), angels and archangels, Jesus Christ and the Virgin Mary (the two most frequently portrayed images), figures taken from the Old and New Testaments, mystics, and Christian martyrs. These representations corresponded to a conservative iconogra-

phy, and identities were usually established by means of accompanying symbolic attributes which alluded to a culminating spiritual moment, to the circumstances of martyrdom, or to some notable deed or action of the person. In the seventeenth century a number of Spanish saints such as San Isidro Labrador, San Ignacio de Loyola, San Francisco Xavier, Santa Teresa de Jesús, and others were added to this roster. Commemorative engravings issued at the time of their canonization did much to fix a definitive iconographic formula, which in some cases included the physical likeness of the individual portrayed. Such single carved and polychromed statues were those chiefly exported to the colonies.

These carved and polychromed wooden statues were the product of a closely regulated guild system in which apprentices and journeymen worked under the guidance of an acknowledged and licensed master. In Spain the sculptor was the product of a long and honored tradition. As an artist he belonged to a cultural and intellectual elite. The Spanish sculptor was expected to have a thorough knowledge, both theoretical and practical, of anatomy and draftsmanship as well as of the technical processes involved in the carving and completion of a statue. As a master craftsman of distinction, he was accorded honors commensurate with his individual excellence and originality.

Sculptors and painters, each members of different guilds, collaborated in the finished product. In the first stage, preliminary sketches and occasionally clay models of the subject were rendered by the master sculptor, and the wood—cedar, black oak, and pine were preferred—was chosen. The carving was then given its rough form. This work was often relegated to apprentices, although in the final stages the master took charge. Once the carving was completed, any knots or other imperfections in the wood were covered with strips of cloth glued into place. The statue was then covered with five or six fine layers of gesso, carefully applied and smoothed between each application so that no detail of the carving would be slurred, and finally it was sized with Armenian bol or a similar clay ground. If the clothing of the statue was to be decorated with *estofado*, then the appropriate area was covered with gold leaf, moistened and glued into place, and burnished with agates shaped for this purpose. The carving was then turned over to the painter's guild to receive its final decorative elaboration.

Here different techniques were employed in accordance with the nature of the area to be represented. If flesh was to be shown—face, hands, feet, or unclothed torso—

the process known as *encarnación* was employed. Oil paint was applied, its color and hue chosen in consonance with the subject and theme depicted. The line of the eyebrows, the lashes, the reddened lips, or other similar details were applied before the paint was completely dry. The surface was then either left dull, *encarnación matte*, or else highly polished with a soft leather cloth, *encarnación brillante.* In sixteenth- and early seventeenth-century statues, the eyes were carved as an integral part of the face. About 1630, it became the custom to carve the head of the statue in two pieces. Once the inner surface of the face had been hollowed out, glass eyes were firmly glued into the sockets and the two pieces so carefully rejoined that the seam was invisible. In some cases the face was not carved of wood but made of a lead casting called a *mascarilla de plomo.* This was affixed to the face of the statue and then painted. The hands of a statue might also be made of such lead castings.

The areas intended to represent clothing were painted in processes known as *estofado* or *policromía.* In the *estofado* process, the gold leaf was covered with a layer of oil paint. This was then incised with a pattern of very fine parallel lines, *sgraffito*, to reveal the underlying gold ground, and to simulate the gold thread of the most elegant contemporary brocades. Frequently, the surface was then further decorated with a variety of floral and abstract decorative motifs. In the *policromía* technique, which became popular after 1630, the layer of gold leaf was omitted and the statue painted directly with various patterns highlighted in gold. The technique known as *corlas* was a composite of these two techniques. A base of silver leaf was applied, covered with a thin layer of transparent lacquer which in turn was embellished with designs. Employed in Spain in the sixteenth century, this method was known as *estofado a la chinesca* for its similarity to the translucence of oriental lacquerware by which it may originally have been inspired. The use of *corlas* became increasingly popular in the colonies during the eighteenth century.

Not all images were fully carved. Some were of the type known as *de vestir* (literally "to be dressed"), a style which became increasingly popular in the seventeenth century. The face, hands, and feet of *de vestir* images were carefully finished while the rest of the body was carved and painted in a cursory manner. In extreme cases the body of the figure was reduced to a rudimentary framework. The joints at the elbows and shoulders were often articulated to facilitate dressing these images in the silks and brocades

with which they were usually adorned. A subsequent derivation of this technique was the use of *tela encolada*. Cloth was impregnated with gesso and glue, molded into shape, allowed to dry, and then painted. It served either to replace or to supplement carved clothing such as cloaks, mantles, or loincloths.

Few works of Spanish sculpture were ever signed, although in a number of cases the fame of the artist and the excellence of his sculptures ensured that their origins would long be remembered. In many instances, however, the provenance of statues remains unclear, and scholars often disagree on attributions. This task is complicated by the fact that many of Spain's historic archives have been destroyed or have disappeared, thus depriving the scholar of access to documents which might serve as a logical basis for such determinations.

With respect to Spanish statues shipped to the colonies, even less information is available. The chief source for such data remains the Archives of the Indies in Sevilla. Here numerous bills of lading have come to light. However, most of these entries refer only to "baled art goods" and thus fail to provide any specific information about their content. In Quito the difficulty is further compounded since access to the archives of the religious orders has been severely limited, and other more readily available archives have yet to be catalogued and thoroughly studied. While it is known that a few individuals commissioned images directly from Spanish workshops, by far the greatest number of Spanish statues imported to the colony must have been ordered by the various religious orders, either in Spain or in Quito, although the exact nature of such transactions remains unknown.

In the absence of supporting documentary evidence, the scholar is forced to rely on meticulous visual analysis. A thorough knowledge of the history of Spanish sculpture serves as an indispensable foundation for such analyses, as does a knowledge of iconography, of technique, and of style. All of these factors are subject to constant change—one historic period may emphasize a certain saint and the following one ignore him, or else a certain iconographic representation may be introduced and remain in vogue for a while, only to be later replaced by another. Techniques are forever changing as well and provide valuable clues. For instance, the discovery of a seventeenth-century gold-based *estofado* under a later overpainting, as in the case of a statue of Saint Francis, helps to determine the date of a statue. However, an attribution can never rest on one isolated in-

Plate 3

dication but must include various factors, all of which must function in unison to corroborate each other. In the following pages, when no documentary source is cited as evidence, the attribution of a statue to a known sculptor or to a workshop is the author's and was arrived at through such a detailed visual analysis.

The sculptors whose names figure most prominently in the Spanish archives and whose works were most frequently exported to the colonies were, according to the Spanish art historian the Marquez de Lozoya, those of Juan Bautista Vásquez, Francisco de Ocampo, Juan Martínez Montañés, Juan de Mesa, and Pedro de Mena. Images from all of their workshops appear in Quito. Works attributed to the lesser known artists Gaspar del Aguila and Jerónimo Hernández are also represented. With Gaspar del Aguila our story begins.

3 Sixteenth Century Sevillian Sculptors

Gaspar del Aguila

Gaspar del Aguila was born in northern Spain, in Toledo, around 1560 and emigrated to Sevilla soon after Vásquez the Elder, whose disciple he became. There he spent the remainder of his life. Though few of his works have been identified, his considerable prestige can be inferred from the frequent documentary references to commissions awarded him in and around Sevilla between 1566 and 1602. In 1579, he carved *La Virgen de Trebujena*. One Quitenian statue of Virgin and Child bears such a close resemblance to the Spanish image that it must be attributed to him and assigned a similar date. This high-waisted figure of the Virgin, sheathed in gold, stands immobile within its enclosing contours, animated only by the severe geometry of the drapery and the cold pallor of the *encarnación*. Naturalistic detail in the column-like figure has been suppressed in favor of formal, abstract design indicating the presence of lingering Gothic characteristics barely warmed by the new Renaissance currents. Several statues, similar to this one, can be found in both public and private art collections in Quito. They are among the earliest figures to have arrived in the colony and must all belong to the same general period, c. 1580–1600.

Plate 1

Jerónimo Hernández

One figure of the Virgin and Child reveals the definite shift toward the Roman Renaissance style. The proportions of the carving are Michelangelesque. The boldly rounded

Figure 3

forms and the *contrapposto* in the pose of the Child Jesus recall an image carved by the Sevillian sculptor Jerónimo Hernández and entitled *La Virgen de la Paz* (1579–83). Gisbert and Mesa have found documentary evidence that this artist's work was sent to Bolivia. This means that Hernández exported his work to the Indies, and it seems possible that one of his carvings also found its way to Quito. The Quitenian image has been badly damaged; it was a common practice in the eighteenth century to trim protruding draperies from older statues, thus adapting them to the increasingly popular *de vestir* mode and clothing them in real garments. Because of its poor condition, definitive attribution of this carving to Hernández is virtually impossible though its presence helps to establish the fact that statues of this early date and of this particular style did reach Quito.

The Vásquez Workshop

Another figure of similar ample Renaissance proportions portrays Santa Catalina of Alexandria, an early Christian martyr. Both the full-bodied form and the wealth of finely pleated drapery recall the designs of classical antiquity. This statue has been attributed to Juan Bautista Vásquez, but a distinction must be made between father and son both of whom were sculptors. Juan Bautista Vásquez, the Elder, was born in northern Spain; he worked as a sculptor, painter, and engraver in Toledo from 1554 to 1556. In 1557, he moved to Sevilla and is generally credited with initiating the Sevillian school of sculpture. He transmitted his knowledge of Renaissance style to his disciples, among them Gaspar del Aguila, Jerónimo Hernández, Andrés and Francisco de Ocampo. At his death in 1569, his workshop passed into the hands of his son, Juan Bautista Vásquez, the Younger.

According to Fr. Vargas, Quito's leading art historian, the son of the Inca Atahualpa commissioned this image of Saint Catherine in Sevilla in 1588 from Juan Bautista Vásquez. This must refer to Vásquez, the Younger. The statue now occupies a place in the central niche of one of the four altars in the central patio of the Monastery of San Francisco in Quito. The other three altars contain images of Saints Inez, Cecilia, and Lucia, which, according to Quito's first art historian, José Gabriel Navarro, are also "works of the great sixteenth-century sculptor, Juan Bautista Vásquez, commissioned by one of the grandsons of Atahualpa for his private chapel in the Church of San Francisco."[2] Navarro did not cite any document to support his claim, however. While the statue of Saint Catherine reveals an affinity to

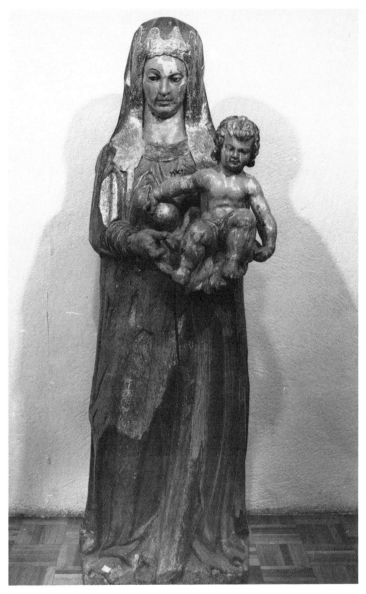

3. Jerónimo Hernández. *Virgen con el Niño*, 1580–90. Museum
of the Banco Central del Ecuador, Quito. Photo Instituto
Nacional de Patrimonio Cultural del Ecuador.

the Vásquez style, the other three statues differ from it and
from each other, thus making Navarro's attribution diffi-
cult to support.

　　At about the same time that these early Spanish images
reached the Audiencia of Quito, in the last decades of the
sixteenth century, the first known Spanish sculptor, Diego
de Robles, emigrated to this corner of the New World in
search of adventure and economic advancement. Though

the name of Diego de Robles is one of the best known in Ecuadorian history, it is possible that other Spanish sculptors were at work in Quito during this period. In time their names may be uncovered, and it will become possible to reconstruct the very beginnings of colonial art in Quito in greater detail. For the moment, Diego de Robles must stand as the representative of a whole class of anonymous artists and artisans who introduced to Spanish America the techniques of European arts and crafts, which were to play such an important role in the cultural life of the New World.

Diego de Robles

Unlike towns in Bolivia, with their proximity to gold and silver mines, Quito could boast neither great nor sudden wealth. As a result fewer Spanish artists are known to have emigrated to this area and worked here in the early days of the colony. One of these was Diego de Robles. A native of Toledo, Robles worked at the Escorial and at Aranjuez in central Spain. Like many artists, he appears to have emigrated to the south, for in 1575 a documentary reference places him in the workshop of Jerónimo Hernández. In this record, Hernández authorizes "my apprentice, Diego de Robles, to go to the village of Haznalcollar and to collect 6,000 maravedís [an old Spanish coin] from the majordomo of the church as partial payment of the 60 ducats owed me for an image of Our Lady and a tabernacle which I have made for the church" [translation mine].[3]

In 1584, he decided to emigrate and was awarded a royal license to take "swords, daggers and an arquebus" with him to the province of Quito. That same year finds him working in the colony and commissioned to carve a figure of the Virgin.

He stayed in Quito until the end of his life. His will, dated March 4, 1494, provides a rare human glimpse into that distant past. Robles indicates that though he is in the best of health, he wishes to arrange his affairs so that death will not catch him unaware. He complains about the difficulties and long delays in conducting business in the colonies and emphasizes that all his possessions have been gained through his own efforts. He is spiteful about the failings of his wife, and, to make his point, bequeaths all of his belongings to a son and daughter. Finally, he asks to be buried in a Franciscan habit and to be accompanied to the grave by the members of the lay brotherhood to which he belongs.

Robles's first documented work, commissioned by a brotherhood of merchants, was a copy of the revered image

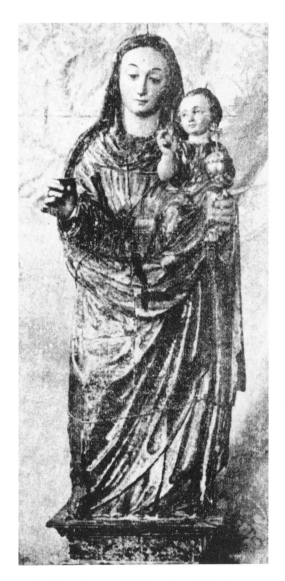

4. Diego de Robles. *Virgen del Quinche*, 1588. Sanctuary of
Guápulo, Quito.

of La Virgen de Guadalupe of Estremadura, Spain. Luis de
Rivera (d.1619), with whom Robles is believed to have es-
tablished a workshop in Quito, was hired to paint and gild
the carved statue, *encarnarla y estofarla*. Located in the
Franciscan sanctuary at Guápulo near the outskirts of Quito,
this image was destroyed in a fire in the nineteenth cen-
tury. In 1586, Robles was commissioned to carve a crucifix
and an Immaculate Conception, sculptures which have since
been lost. The one documented image by Robles still extant
is known as *La Virgen del Quinche*. Originally commis-
sioned by one parish, then sold to another, it finally came

to rest at the Santuario de Guápulo. The Virgin, about four and a half feet high, is portrayed as a formal, hieratic image. The compact, closed silhouette is disposed on a symmetrical, vertical axis, elbows close to the body, hands near the waist. The mantle curves over the head and shoulders, forming an accentuated arc below the waist. This image has been badly damaged and repeatedly restored. Thus it is virtually impossible to isolate and to ascertain this sculptor's essential stylistic characteristics and to attribute other carvings to him, although this is routinely done.

The single most significant characteristic in these late sixteenth-century statues is an emphasis on the closed silhouette, on the dominance of the enclosing contour. This feature is particularly noticeable in the two figures of the Virgin and Child, one by Gaspar del Aguila, the other by Diego de Robles. However, within their enclosing contours it is possible to trace a slight but increasing sense of inner vitality and warmth, as if a new force were stirring. Similarly the seeds of European civilization made the passage across the vast ocean and were planted in new soil. There they flourished and took on new being.

Chapter Three

4 Seventeenth-Century Sevillian Sculptors

Francisco de Ocampo

In both Sevilla and Granada, at the end of the sixteenth century, the formal aspects of the Renaissance traditions gave way gradually to more realistic, less abstract artistic expression. Portrayals of Christ and of the Virgin Mary became more tangibly human. To these were added growing numbers of individual saints, idealized versions of mankind, in whom principles of spiritual and physical beauty were fused. This turn toward Realism is illustrated in the statue *Jesús Buen Pastor* in the museum of the Franciscan monastery in Quito. It can be attributed to the workshop of the Sevillian sculptor, Francisco de Ocampo, a workshop inherited from his uncle Andres.

Francisco de Ocampo is known to have carved a *Jesús Nazareno* in 1607, and later, in 1622, a figure of San José. The earlier is the more classical figure, the face finely modeled, the body bent in paraphrase of the burdened spirit. The second image is more prosaic and already clearly influenced by the currents of Realism. The Quitenian *Jesús Buen Pastor* bears a striking resemblance to Ocampo's 1622 San José, not only in general design, but in specific detail. The round-necked tunics are similar as is the manner in which the finely articulated pleats radiate above and below the knotted belt. Also similar is how the cloth on the right sleeve forms vertical folds above the elbow, horizontal ones below it. However, the general lack of subtlety and crispness in the Quitenian carving suggests that, while this statue

Plate 2

25

was based on an Ocampo design, its execution was left to a workshop assistant.

Juan Martínez Montañés

The influence of the Italian Renaissance is apparent in the works of one of Spain's greatest sculptors, Juan Martínez Montañés. His early works reveal a close allegiance to the Italian ideal—a strict classicism with the human body portrayed in a vigorous, monumental fashion. By the time he had reached his maturity, however, his was a purely Spanish idiom and a distinctive personal style. This style was to dominate much of Andalucian sculpture for years to come.

With the art of Juan Martínez Montañés (1568–1648) Sevillian sculpture achieves a pinnacle of excellence, and the style of Realism reaches one of its highest moments. In 1588, at the age of twenty, Montañés passed the requisite examinations and obtained a license to practice as a sculptor and an architect. Though he traveled little, the Sevilla in which he spent his long lifetime was at the height of her wealth and cultural vitality. The force of Montañés's style, which has been termed impassioned classicism, and the vigor of his artistic personality dominated Sevillian sculpture during the entire first half of the seventeenth century.

He designed many altars and high-relief panels, but it was the isolated image on which he bestowed his greatest measure of creativity. Many of these sculptures—figures of the Immaculate Conception, Saints Francis and Dominic, John the Baptist, and John the Evangelist—became definitive prototypes and were endlessly copied. He portrayed real people, often thoughtful and self-absorbed. Their individual humanity, though idealized, was immediately felt; the depth of their character was revealed as a subtly directed spiritual energy.

Montañés's professional life is generally divided into three periods. From 1590 to 1620, his art was most strongly influenced by the Italian Renaissance. By 1620, however, a more original and forceful personal style based on realism emerged. The next ten years were busy ones during which he was surrounded with disciples and collaborators. In this period the largest number of images from his workshop were sent to Spanish America. After a grave illness, Montañés entered into a new period of creativity which lasted until shortly before his death in 1648. During these years he produced a number of individual statues of great power,

their explicit emotional qualities already signaling a turn toward the Baroque.

There are three statues in Quito—of San Diego de Alcalá, of San Francisco, and of the Virgin Mary—which bear a close relationship to the work of Montañés. These all belong to his most active period (1620–30), and while they were in all likelihood based on his designs, they were carved by other artists with whom he collaborated closely.

San Diego de Alcalá was a Franciscan friar, born in Andalucia. He came to be much loved and venerated for his simple piety and his miraculous ability to cure the sick. Early in his career Montañés was commissioned to carve statues of this saint. According to the art historian Beatrice Gilman Proske:

Orders for the statues began to come in rapid succession. A San Diego, ordered on July 19, 1590, and destined for a church in Ayamonte [Spain], was to be like the one that Montañés had carved for a Franciscan monastery at Cádiz. A year later another San Diego for another monastery dedicated to him in Sevilla was to be life-size, of pine, the habit gilded, and decorated with *sgraffito*, one of the processes of *estofado* polychromy.[4]

A life-size image of this saint stands in one of the side altars in the small Quitenian convent church of San Diego, formerly a Franciscan retreat. The robust figure stands with its head slightly turned and raised. The habit falls simply and naturally, in broad, smooth planes, breaking at the knees into a series of more complex folds. Though none of Montañés's carvings of San Diego has survived, comparison of the Quitenian San Diego with one of Saint Francis carved in 1622 by Montañés reveals a close similarity between the two in stance and gesture. The angle of the arm and of the raised face, the proportions of the body, and the general characterizations all place the Quitenian statue squarely in the Montañés tradition. The modeling of the face, however, reveals none of the spiritual depth which one associates with the work of Montañés himself. The fine *estofado* with its remarkable precise *sgraffito* is one of the very finest examples of its kind in the colonies. This statue was frequently copied in the eighteenth century by colonial artists.

Another sculpture in Quito which clearly proclaims a relationship to the Montañés style is a life-size image of San Francisco de Asís which presently stands in an enormous mirrored altar in the church of San Francisco. This image portrays the saint gazing at a crucifix he holds in his right hand. Montañés is known to have carved an image of St. Francis as early as 1591. No trace of this statue has

Figure 5

Figure 6

Plate 3

Seventeenth-Century Sevillian Sculptors

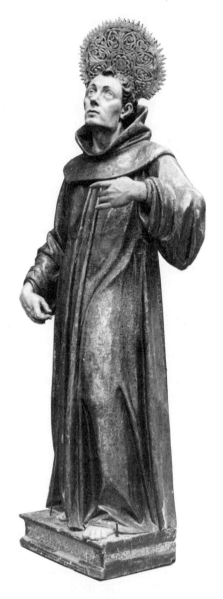

5. Circle of Martínez Montañés. *San Diego de Alcalá*, c. 1622.
Convent of San Diego, Quito. Foto Hirtz.

been discovered. In the course of his long career, Montañés
carved several other images of this subject, one of the best
in 1622 for the Convent of Santa Clara in Sevilla. Com-
parison of this Spanish statue with the Quitenian Saint
Francis reveals a strong resemblance in style and icono-
graphic type, in gesture, demeanor, and pose. The Quiten-
ian image is slimmer and carries with it a suggestion of
relaxation from the vertical, the draperies articulated in
fine pleats; the Sevillian statue is more robust, the habit

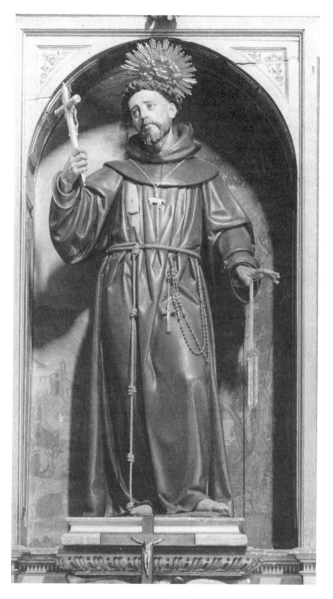

6. Juan Martínez Montañés. *San Francisco de Asís*, 1622.
Convent of Santa Clara, Sevilla, Spain. Foto Mas.

carved in broader planes. The Montañés image is the more
ardent portrayal, while the Quitenian is cooler and more
aristocratic, and reveals less spiritual depth and intensity.
The Quitenian image appears to be the work of an anon-
ymous sculptor with whom Montañés worked closely.

While Montañés was at work on the commission for
the Convent of Santa Clara for which he personally com-
pleted two altars, two other retablos were also planned to
honor Saint John the Baptist and Saint John the Evangelist.

Based on a design by Montañés, the central images of these two retablos were executed by an unknown but highly skilled assistant. According to Proske,

> The statues digress from the style of Montañés as it appears on the other two retablos. . . . The poses and the draperies are completely in his tradition, but although the modeling is very fine, it betrays a new and distinct personality, suggesting that Montañés designed these statues but gave their execution to another sculptor. . . . The Evangelist is a young man with a small moustache and beard . . . the face is a more delicate, aesthetic type with finely chiseled features and thin cheeks.[5]

Figure 7

Comparing this Sevillian figure of Saint John the Evangelist with the Quitenian figure of Saint Francis, similarities of both concept and style become apparent. The faces of both images are characterized by intelligent, slightly remote expressions. The temples are indicated by a shallow depression, the eyes are set in the face in a similar manner, the angle of the gaze is identical, the hands and feet are modeled with aristocratic delicacy, and draperies are articulated in a like manner to form a series of narrow, crisp pleats which radiate from the waist. Similar too is the exaggerated length from waist to knee of the bent right leg.

This Quitenian statue of Saint Francis, along with a number of other Spanish images, was at some time overpainted a dark brown, highlighted with gold designs. In several places this paint has worn through and it is possible to see the original seventeenth-century *estofado* underneath—the Armenian bol, the gold ground. The design of the *sgraffito* appears to be similar to that of the statue of San Diego. It seems likely that the sculptor of the Sevillian Saint John the Evangelist carved the Quitenian statue of San Francisco as well.

Plate 4

A smaller statue of the Virgin Mary, in the museum of the Banco Central, which once held an image of the Christ Child in her left arm, falls within the same Montañés tradition and belongs also to the 1620–30 period, though it more clearly reveals the individual character of its author. The serene oval face is a study in grave classicism. The *estofado*, in a remarkable state of preservation, is of extreme beauty. The garnet red gown is decorated with figures of angels and Renaissance grotesques, while the dark green mantle, falling to the floor in heavy folds, is painted with a pattern of flowers and edged with a wide contrasting border. The resonance of the colors is echoed in the intricate rhythm and the slow fall of the draperies. The design of the drapery, the elongated thigh (the proportion from waist to floor is identical to that of the San Francisco pre-

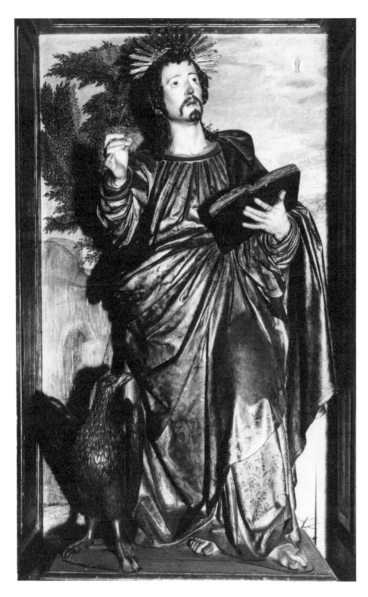

7. Circle of Martínez Montañés. *San Juan Evangelista*, c. 1620–25. Convent of Santa Clara, Sevilla, Spain. Foto Palau.

viously discussed), as well as other similarities in details and in general style, indicate that the same Spanish sculptor carved this figure. One further detail links it directly to the Montañés workshop: the right hand of the Quitenian image is identical to one which Montañés used in a statue of Saint Joseph for the Sevillian church of San Antonio Abad. The original design must have been executed by Montañés, and a master mold made in his workshop. From this mold a series of hands were subsequently cast to be used on other statues such as the Quitenian example.

Juan de Mesa

Montañés had few worthy disciples, with the exception of Juan de Mesa (1583–1627), whose career was brilliant but tragically brief. He worked with Montañés and based many of his own works on the former's prototypes, though he infused them with greater emotionalism and decorative exuberance. With him the emphasis shifts to a more overt and emotional expression, to portrayals of "aesthetic and penitent saints, and themes taken from the Passion. . . . He is in a way," says Gómez-Moreno, "the first Baroque artist."[6] In the second decade of the century he established his own workshop, dedicated in large part to the production of processional images of the *de vestir* type. Only partially carved, these were meant to be clothed in imitation of high society in real brocades and silks. With the work of Mesa there is a definite shift toward such *de vestir* statues. In the course of this development, Realism turned ever more to literal interpretations and to the reproduction of explicit details. The clothing of statues was no longer luxuriously decorated with *estofado*, but was plainly carved and plainly painted. Increasingly it became the custom to fashion face masks from lead or tin molds; glass eyes were made to shed crystal tears and even decorated with false lashes.

Among the most famous of Mesa's images was a fine figure of the sorrowing Virgin, *Nuestra Señora de las Angustias* (Convent of San Augustín, Cordoba), which he carved in 1627, the last year of his life. Some years ago, in Quito, when *Jesús del Gran Poder* was taken annually from its place in the church of San Francisco to participate in the mournful Good Friday procession, it was preceded by a life-size statue, the *Virgen Dolorosa*, which belongs to the same period and to the same Baroque tradition as the Mesa carving. A close examination of the Quitenian image reveals that the body has been carved in a very simple fashion— the torso is smooth, and the rather full skirt acts as a support for the real clothes with which this figure is meant to be dressed. The face reflects deep sorrow, and the eyebrows are fashioned in an inflected arc, a characteristic popularized by Mesa. Mesa's 1627 image of the sorrowing Virgin bears some similarity to the Quitenian *Virgen Dolorosa*. However, since the face of the colonial image is a metal mask and the body has been carved in such an undefined manner, this statue must be considered a workshop model and allied to Mesa's style only in the most general terms.

Plate 5

5 *Seventeenth-Century Granadan Sculptors*

Alonso Cano

 With Alonso Cano (1601–67) Granada could again claim a sculptor of first rank. Cano worked not only in Granada but in Madrid and Sevilla as well. An engraver, an architect, and well known as a painter, he nonetheless did some of his freest and most original work as a sculptor. Only briefly did he have a *taller* (workshop) in Sevilla, and, though on occasion he collaborated closely with Montañés, he more often worked alone. Renowned as a teacher, Cano seemed able to influence and invigorate those around him. Some of Cano's sculptures were based on established iconography, while others were original creations. Cano both carved and painted his own statues. To the *encarnación* he brought restrained but realistic touches such as a hint of bluish beard on the face of a young San Diego, as well as delicate gradations in the tonality of the flesh and a painted transition of the carved hairline. His *policromía* was unsurpassed in decorative beauty. He treated the carved wooden surfaces as if they were canvases, applying decorations *a punta de pincel*, with a fine brush over a painted, not a gilded ground. In other instances, with painstakingly realistic detail and in subdued colors, the sculptor represented the modest cloth of the Franciscan habit. These innovations in the art of polychromy, which Cano initiated around 1630, were adopted by other artists and gradually came to replace the earlier gold-based *estofado*. This type of decorative finish was used exclusively by colonial sculp-

tors in the eighteenth century. While there is no evidence that any of Cano's works were exported to Quito, a number of statues in that city can be attributed to Cano's disciple and close collaborator, Pedro de Mena.

An Anonymous Sculptor

Figure 8

Many of Cano's portrayals, particularly those of women and children, were touched with tenderness and feel more tangibly human and approachable than the more formal and idealized carvings of Montañés. One unknown sculptor appears to have been influenced by Cano's warmth in a life-size statue of Saint Joseph and the Christ Child. In this carving, the infant Jesus engages in a warm, emotional exchange with Joseph. In some details the carving looks back to an earlier classicism—notably the manner in which the drapery clings to the right leg revealing its contours—while the natural stance and gestures and even the informal manner in which a stray lock falls on Joseph's forehead reveal the stylistic influence of Realism. The face of this statue is made of a metal mask of the type cast in a series from a master mold, and it is interesting to speculate whether one generic type may have been used for more than one purpose, to depict a number of saints, since individual facial characteristics played little part in the portrayal of such figures. The carving of the drapery shows considerable skill, although some of the details have been coarsened and the seventeenth-century *estofado* has been concealed by an overpainting, probably done during one of the many renovations of the Cathedral of Quito. The iconographic type of Joseph with the Christ Child in his arms appears in Andalucian sculpture around 1640, and this statue may be dated somewhere in the period 1630–50. A number of copies of this Spanish statue were made, one in the Jesuit church of La Compañía and another in the Capilla del Rosario in the Church of Santo Domingo. This fact suggests that the statue was highly regarded and that its Spanish provenance may once have been common knowledge.

The García Brothers

It must be remembered that Granada, like Sevilla, was an important center for art during this period. Among the most notable sculptors were the twin brothers Miguel and Jerónimo García, both of whom were priests. Although they were not well known outside of Granada, their originality did influence some of their contemporaries. Documentary references to their work indicate that the Garcías were active during the first three decades of the seven-

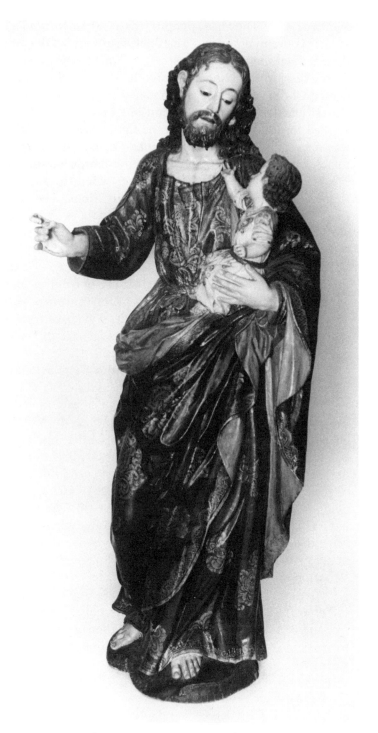

8. *San José con el Niño*, 1630–50. Metropolitan Cathedral,
Quito. Foto Hirtz.

teenth century. They had apprenticed to Gaspar Nuñez Delgado, a contemporary of Gaspar del Aguila in Sevilla, and they derived the principal inspiration for their own works from a bust which Nuñez Delgado had carved of the Flagellated Christ. Their images, modeled in terra cotta, were almost exclusively of the Passion of Christ. The brothers worked together; one modeled the figure, while the other was responsible for its *encarnación*. The heavily muscled torsos were executed with a fine modulation of surface, the facial expressions suggested deep anguish, and the shoulders were covered with deep lacerations. The flesh tones were rendered with great subtlety and the body painted with bluish-green bruises closely juxtaposed to rivulets of brilliant blood red, thus heightening the dramatic and emotional quality of the carving. The output of the Garcías was limited, but the bold and original use of color in their painterly *encarnación* influenced other sculptors who adopted their technique. As the Baroque style became ever more prevalent, so too did this expressive style of *encarnación* which so well suited its theatricality.

Figure 9

The style of several statues in Quito bears a resemblance to that of the Garcías. The first, known as *Cristo de los Azotes*, the Flagellated Christ, occupies a niche in the church of San Francisco at the entrance to the Villacís chapel. It represents the moment when Christ, his hands bound, is about to be scourged. In this carving the *encarnación* is dark and warm in tone. The eyes are not made of glass but carved integrally with the face—details which help to date the statue in the period 1620–30. The pose is natural and the articulation of the anatomy correct. The general concept is sober; there is no expressive use of the nude. Artistic expression is here subordinated to the presentation of a traditional devotional image.

Figure 10

An almost identical statue of Christ occupies the central altar in the Capilla de las Almas in Quito's Cathedral. The anatomical proportions, the articulation of the rib cage, the position of the legs, the manner in which the loincloth rides low on the hips, even the extended forefinger—all these details are alike in the Villacís and cathedral images. They must have been carved by the same man. The cathedral image of Christ is accompanied by a figure of Saint Peter. Iconographically this group represents the repentant Saint Peter kneeling before Christ after he has betrayed Him, although locally it is known as *The Denial of Peter*. The figure of Christ, executed with considerable skill, must originally have been intended to stand alone. Only at some

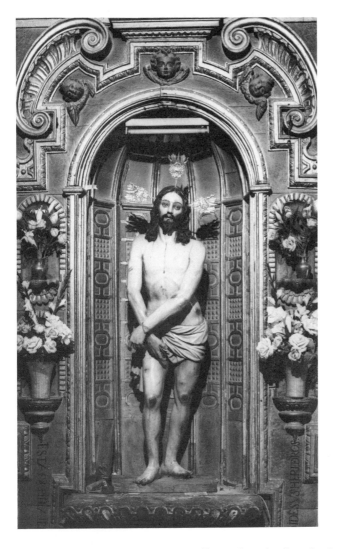

9. *Cristo de los Azotes,* c. 1630–40. Villacís chapel, Church of San Francisco, Quito. Foto Hirtz.

later date was the figure of Peter, a much less distinguished carving, added.

The Villacís and cathedral images differ in one important aspect, however. In the former image Christ's head is upright, while in the latter it is inclined to one side and inscribed with an expression of deep sorrow. A comparison of the face of the cathedral image with yet another statue of Christ, *Jesús del Gran Poder,* one of Quito's most revered images, makes it possible to attribute this sculpture to the same anonymous Spanish sculptor. The design and characterization of both the cathedral image and *Jesús del Gran*

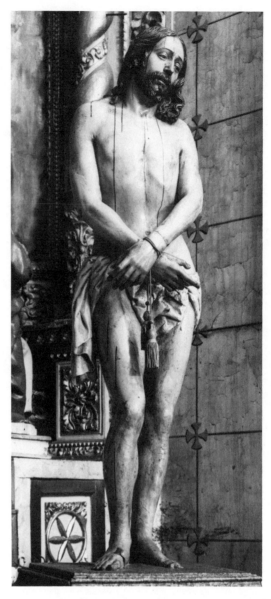

10. *La Negación de San Pedro*, c. 1630–40. Capilla de las Almas, Metropolitan Cathedral, Quito. Foto Hirtz.

Figure 11

Chapter Five

38

Poder are similar. In the former the carving of the face is crisp while in the latter the features have been thickened, no doubt because it has been overpainted.

Jesús del Gran Poder represents Christ bearing a huge cross on his shoulders as he makes his sorrowful way along the Via Crucis. A number of precedents for such a portrayal exist in Andalucian sculpture. Both the Granadan Pablo de Rojas and the Sevillian Francisco de Ocampo carved images of Jesús Nazareno. Later, Martínez Montañés portrayed the

same theme in his *Jesús de la Pasion*, and in 1620, his disciple, Juan de Mesa, executed a processional image entitled *Jesús del Gran Poder*. The Quitenian image which bears the same name is also a processional figure. The clothing is carved in broad planes and very simply painted since the image was meant to be dressed in a brocade robe. A comparison of the Quitenian image with an *Ecce Homo* executed by the Garcías reveals their great similarity. The head in both cases is inclined at the same angle, the hair falls to the shoulder in heavy symmetrical waves, and the features of the face—the full upper lip and the design of the beard—are alike in both examples.

Figures 12, 13

These three Quitenian figures fit well within the conventional iconography of contemporary Andalucian sculpture. The heads of all the images bear some resemblance to the work of the Garcías. However, neither the modeling of the body nor the *encarnación* reveal the emotional intensity which characterized their proto-Baroque style. It may be that these images were carved by a lesser artist who was aware of the Garcías' work and used it as a model.

An interesting controversy surrounds these Quitenian carvings since they are often attributed to an elusive figure known only as Father Carlos. The name Padre Carlos was discovered on the pedestal of a statue of Saint Luke in the church of Cantuña. The inscription attributes the carving of the image to Padre Carlos in 1688 and its renovation to Bernardo Legarda, a prolific Quitenian artist, in 1762. At that time Legarda must have repainted the robes of the statue in the highly decorative polychromy which can be seen today. He covered the statue with fine silver leaf overpainted with a translucent layer of deep blue lacquer; this in turn was decorated with multicolored flowers, a superb example of Quitenian eighteenth-century polychromy. It is possible that, at the time Legarda began his restoration, the image represented some other saint. Legarda added the painter's palette and brush and may then have rededicated the statue to Saint Luke, patron saint of the guild of painters who commissioned him to do the work. This figure of Saint Luke still bears sufficient similarity to the figures mentioned in the preceding paragraphs to be able to assign it to the same sculptor.

Figure 14

José Gabriel Navarro, the Quitenian art historian who studied the Franciscan archives in the 1920s and 1930s, wrote that Padre Carlos was active during the period 1620–80, though again he offered no documentary evidence to support his claim.[7] Since that time no mention of Padre Carlos has been encountered in any historic archives. Ear-

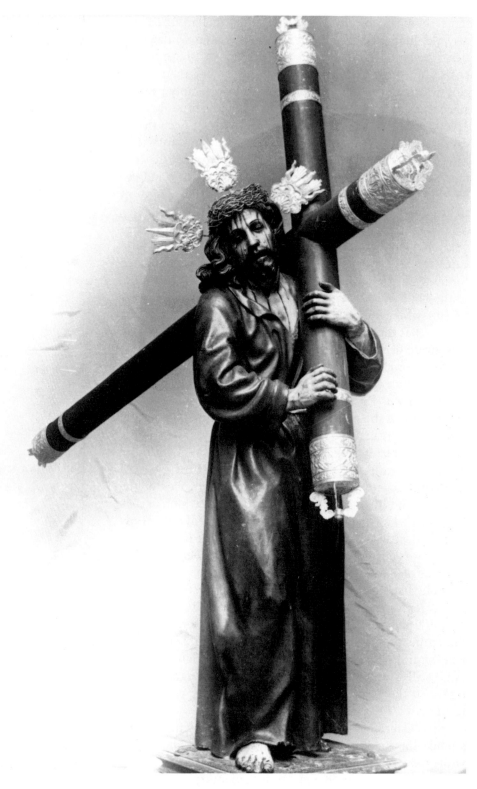

11. *Jesús del Gran Poder*, c. 1630–40. Church of San Francisco, Quito.

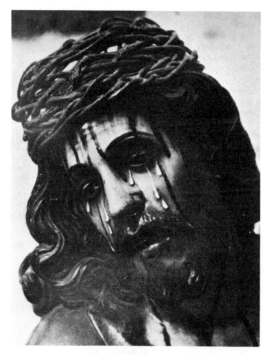
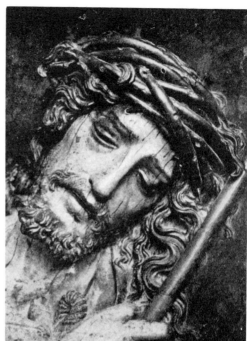

12 (left). *Jesús del Gran Poder* (detail).
13 (right). The García Brothers. *Ecce Homo,* c. 1630. Church of SS. Justo y Pastor, Granada, Spain.

lier, however, Eugenio Espejo referred to Padre Carlos in his book *Primicias de Cultura* (1792) and described him as a contemporary of the native Quitenian painter Miguel de Santiago (d. 1706). He cited three statues—*The Denial of Peter, The Prayer in the Garden,* and *Christ at the Column*—as evidence of the skill of Padre Carlos.[8] Two of these themes correspond to the sculptures previously mentioned, although *The Prayer in the Garden* seems to have been lost. Who was Padre Carlos? Was he perhaps, like the Garcías, a priest and a sculptor as well? Was he too from Granada? Were these statues carved in Quito or were they exported to Quito from Spain? Until more substantial documentary evidence appears to confirm the existence of Padre Carlos, it seems prudent simply to assign all these figures to some unknown Andalucian sculptor at work in the mid-seventeenth century.

Pedro de Mena

Pedro de Mena (1628–88) was born in Granada and learned his craft from his father. He became a disciple of Alonso Cano upon the latter's return from Madrid in 1652, developed rapidly under his direction, and collaborated with

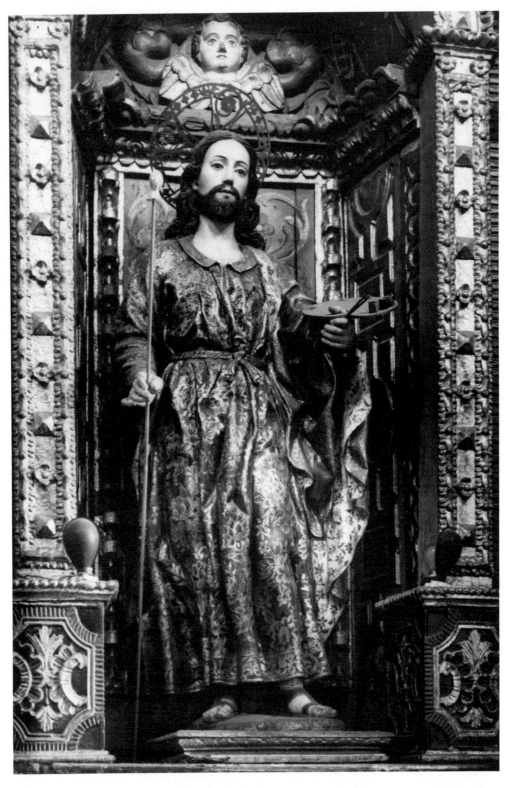

14. *San Lucas*, c. 1630–40. Church of Cantuña, Quito. Foto Hirtz.

him on a number of works. At first he was dependent on conventional iconographic types and influenced by Cano's greater classicism and restraint. As his own style developed, he chose to evoke an even more direct realism, and his work was characterized by explicit representation of religious asceticism and exaltation of overt dramatic intensity. Mena often took his models from life and, once he had created a successful model, it was his practice to restate it in a range of subtle variations. In contrast to Montañés's portrayal of idealized types, Mena's carvings represented identifiable persons with a whole range of individual and expressive gestures. Such figures as Saint Francis in death and Mary Magdalene became definitive prototypes and passed into the general iconography. Through a large and active workshop, the most famous of these models were copied and widely dispersed in Spain and in the colonies. In 1658, he received an important commission to execute the choir stall in the cathedral in Málaga and lived in that city until his death in 1688, leaving no worthy disciple to carry on his work. Speaking of Mena, María Elena Gómez-Moreno, an eminent Spanish art historian, says that the production of his *taller* was so large that no other Andalucian sculptor's work was so widely distributed.[9]

A figure of the Sorrowing Virgin, *La Virgen Dolorosa,* a life-size *de vestir* image, forms part of a group of the Pietá presently in the cloistered Convent of El Carmen de San José in Quito. Though the accompanying figure of the dead Christ appears to be the work of a less accomplished Spanish artist, the carving of the Virgin is of such surpassing excellence that it must be the work of Mena himself. The Virgin mourns the figure of her dead son whose recumbent body lies at her feet. Her face, though smooth and young, is mature in its grief, profound in its compassion, and infinite in its regret. It marks a subtle but significant turn from the Montañés images which, though realistic, were idealized portrayals. The Mena images were not only deeply human but highly individual as well. This very capacity for individualization allowed Mena to deepen and intensify the portrayal of a universal emotion. As exemplified in his brilliant portrayal of the sorrowing Virgin, any purely personal expression of pity has been transcended and transmuted into cosmic compassion. The poise and inner composure of this image indicates that Mena carved it early in his career while still under the influence of Alonso Cano's classicism. In 1658, Mena carved a statue of San Diego de Alcalá—a fine example of this early style. The similarity of *La Virgen Dolorosa*—the smooth planes of the face, the

Figure 15

Figure 16

43

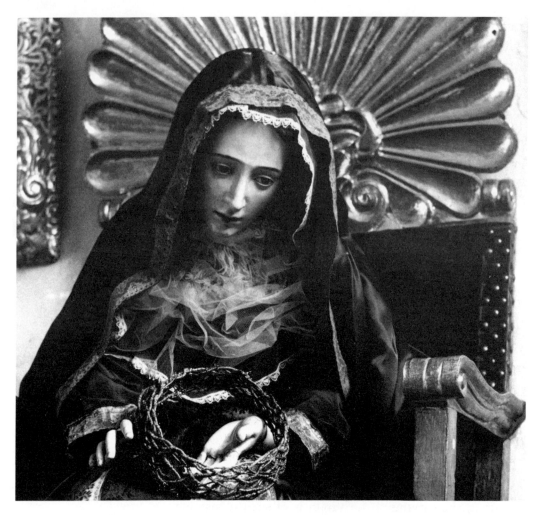

15. Pedro de Mena. *Virgen Dolorosa*, c. 1658–75. Convent of El Carmen de San José, Quito. Photo G. Palmer.

shape of the mouth and nose, and the deeply moving expression—to the *San Diego* suggests that the Quitenian image was carved during the same period. Mena's modeling of hands was always delicate and often poetic. The position of the Virgin's left hand, palm held upward with fingers spread apart, is a typical Mena gesture and one which he used again in his 1675 carving of San Pedro Alcántara.

There is one life-size Quitenian carving of San Pedro Alcántara which bears a close stylistic resemblance to the Spanish statue of the same subject, as well as a likeness to a bust of San Ignacio, which Mena executed for a Dominican convent in Málaga. Gómez-Moreno classifies the portrayal of San Pedro Alcántara as Mena's first original creation and indicates that it may have been based on life studies

Figure 17

44

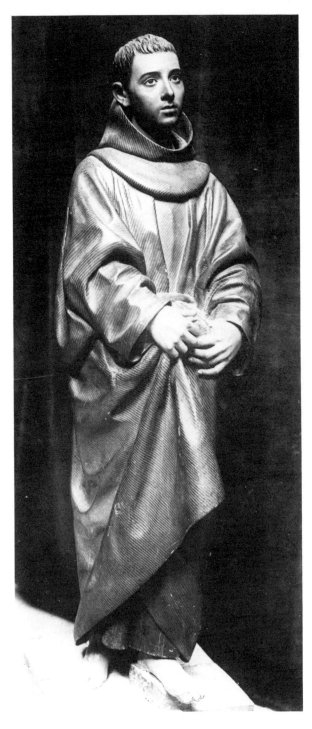

16. Pedro de Mena. *San Diego de Alcalá,* c. 1658. Church of
San Antón, Granada, Spain. Foto Mas.

x

*Seventeenth-Century
Granadan Sculptors*

x

since there were no known antecedents in sculpture.[10] Such realistic and expressive heads became a hallmark of Mena's art. San Pedro was private confessor to Santa Teresa de Avila, author of a well-known treatise on meditation, and also the leader for the reform of the Franciscan Order, a movement which became popular in the colonies. The Quitenian sculpture of San Pedro occupies one of the retablos which line the nave of the small beautiful church of Cantuña. In his right hand the saint holds the cruel metal scourge with which he has inflicted the deep wounds covering his back and chest, evidence of the known severity of his penances and mortifications. This particular type of explicit realism with its painterly emphasis on blood and wounds, though already seen in the work of the Garcías, is not apparent in Mena's work until his later years. However, this Quitenian figure is probably a workshop carving since Mena's own work was always, even in his later phase, more restrained and circumspect.

Figure 18

One of Mena's most famous creations was a statue of San Francisco de Asís. Though earlier models for such a sculpture did exist, Mena's design was probably based on a design by Cano. It portrays the mummy of the saint which, legend has it, was found miraculously preserved when it was exhumed by ecclesiastical authority in the fifteenth century. Mena's carving, which was executed in 1663, shows Saint Francis wrapped in his habit, his face shadowed by the cowl, his hands deeply buried in the sleeves. Copied in Mena's own *taller*, it was endlessly imitated, and many examples found their way to the colonies. In Quito, although there are numerous examples of these copies, only one bears a close relationship to Mena's style. Although similar to the Mena original, even to the detail of the missing tooth, the Quitenian San Francisco de Asís is a life-size image, while Mena's carving was four feet high. Only the hands, feet, and head of the Quitenian sculpture are fully carved; the body is shrouded in a dark cloak made of *tela encolada*. The gaunt face is forcefully modeled and painted with an appropriate death-like pallor. This statue, found in the Quitenian museum Fray Pedro Bedón, is a workshop model and may be assigned a date in the 1660s. This is also true of a companion statue of Saint Dominic.

Figure 19

Figure 20

Another figure, a life-size image of the Ecce Homo, in the Franciscan Museum, is somewhat reminiscent of Mena's style. Mena carved a number of busts of this same subject, and they bear some stylistic similarity to the Qui-

Figure 21

Text continues on page 52

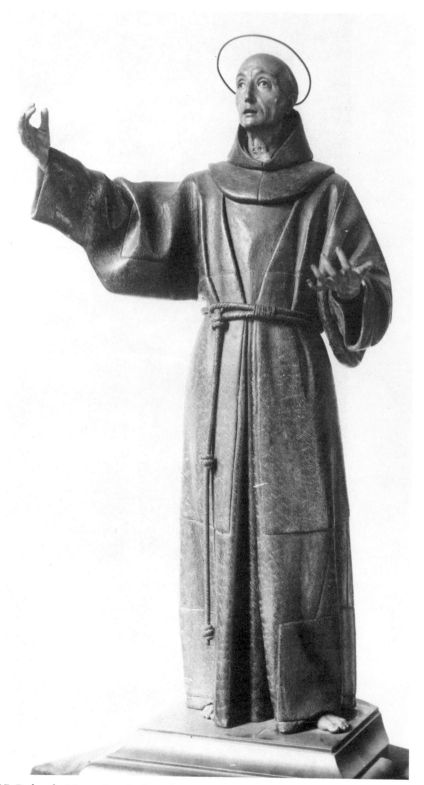

17. Pedro de Mena. *San Pedro Alcántara*, 1675. The Güell
Collection, Barcelona, Spain. Foto Mas.

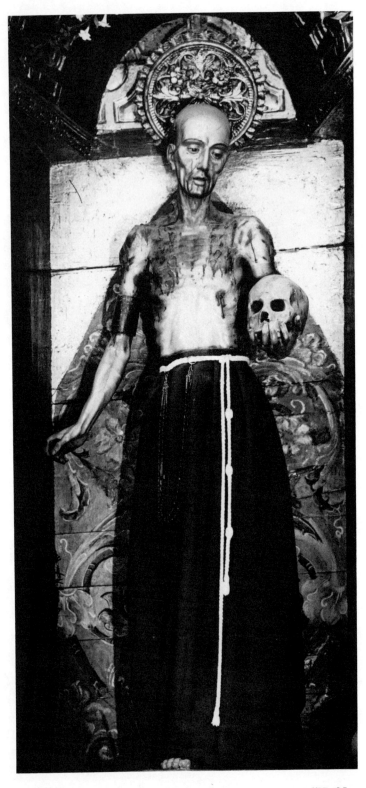

18. Circle of Pedro de Mena. *San Pedro Alcántara*, c. 1675–85. Church of Cantuña, Quito. Foto Hirtz.

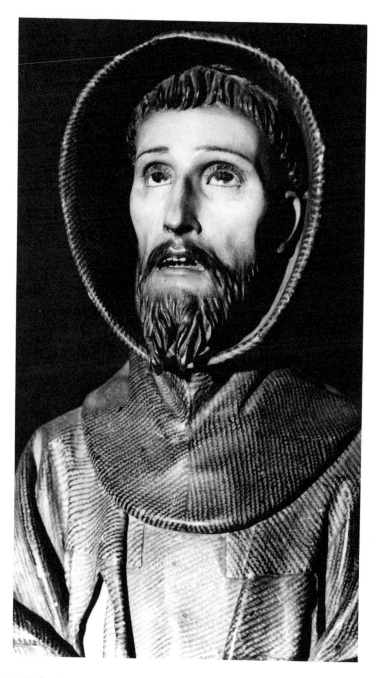

19. Pedro de Mena. *San Francisco de Asís*, 1663. Metropolitan
Cathedral, Toledo, Spain. Foto Mas.

49

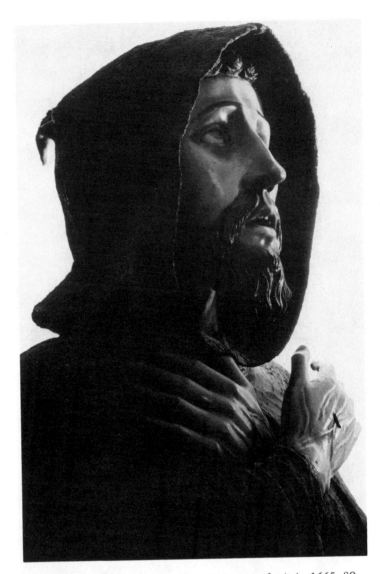

20. Circle of Pedro de Mena. *San Francisco de Asís*, 1665–80. Fray Pedro Bedón Museum, Convent of Santo Domingo, Quito. Foto Hirtz.

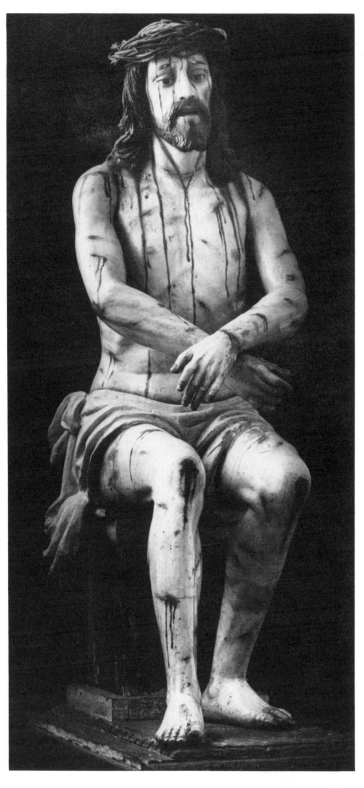

21. *Ecce Homo,* late seventeenth century. Museum of the
Convent of San Francisco, Quito. Foto Hirtz.

tenian image in the general position of the head, the length of the neck, and the extended forefinger of the right hand. This statue may be the product of Mena's *taller*, or of some other contemporary Spanish workshop, although in the late seventeenth century close parallels to Spanish sculpture become increasingly difficult to make.

The works of Pedro de Mena in general mark the end of the period of significant Spanish exports to Quito and serve as well to illustrate that Spain's golden age of sculpture was coming to a close. With the advent of the Neoclassical style, polychrome wood sculpture waned in popularity. One of the few Spanish sculptors to perpetuate the seventeenth-century tradition was Luís Salvador Carmona (1709–67). While it is not known that Carmona himself exported any statues to Quito, one crucifix reveals certain similarities with his style.

Representations of the nude human figure, though common in Italy, were considered pagan in Spain and were generally repugnant to the Spanish temper. The significant exceptions were carvings of the Crucified Christ which provided Spain's greatest sculptors unparalleled opportunities to display their skill in the portrayal of human anatomy in a dramatic and deeply moving context. Indeed, Rojas, Mesa, Cano, and Montañés all carved such images, many of them life-size. While some large crucifixes were exported to Spanish America, many were smaller than life-size.

Figure 22
In Quito, there are a great number of these carvings, some fashioned of ivory, others of wood, some Italian in origin, others from Spain. This category of sculpture is a broad and complex one and deserves a study of its own.
Plate 6
One crucifix does, however, need to be mentioned here. In this carving the nude body of Christ is disposed in a long, fluid arc and turned in a very slight *contrapposto*. The features are small and delicate, and the body is painted with many rivulets of blood and bruises. The design of the loincloth exposes the right thigh and is caught up on the hip in a distinctive knot, while a double strand of rope crosses the left hip, folds of cloth falling below it. This carving belongs squarely in the seventeenth-century Andalucian tradition. The design of the loincloth, the manner in which the knot over the thigh stands away from the body, suggests it was executed either at the very end of the seventeenth or in the early decades of the eighteenth century. Compar-
Figure 23
ison of the Quitenian carving with a Carmona crucifix reveals their striking similarity. In the absence of any more precise documentary evidence, it must be considered the work of an unknown Spanish artist and an example of one

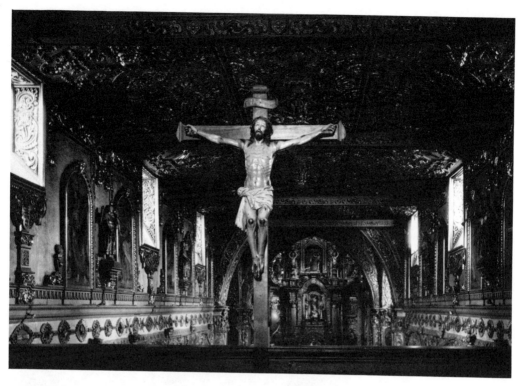

22. *Crucifijo,* seventeenth century. Choir loft of the Church of San Francisco, Quito. Foto Hirtz.

of the few Spanish sculptures of this late date that had an influence on native Quitenian sculpture. It was copied many times by eighteenth-century colonial artists. The Museum of the Banco Central del Ecuador owns at least a dozen of them, and they are often encountered in other collections.

Summary

 With the death of the playwright Calderón de la Barca in 1681, Spain's golden age of literature ended. The great period of Andalucian sculpture also drew to a close. Both the quality and quantity of its sculptured works declined, and exports to the Spanish colonies were drastically reduced. The collapse of Spain's economy and the deterioration of her culture toward the end of the seventeenth century were reflected in the works of the contemporary Spanish sculptor José de Mora, whose tortured images seem to be caught in the grip of inconsolable sorrow. This emotion had already been anticipated in some of Pedro de Mena's earlier images—San Pedro Alcántara's anguish, the face of Saint Francis entombed in its own shadows, and the sorrow of the Virgin Mary presiding over death. It is as if these

Seventeenth-Century Granadan Sculptors

53

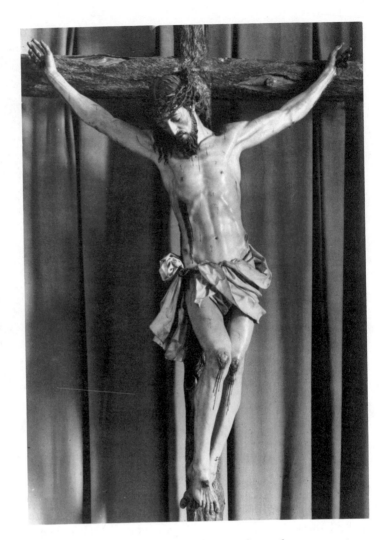

23. Luis Salvador Carmona. *Crucifijo*, eighteenth century.
Museo de Bellas Artes, Valladolid, Spain. Foto Mas.

late seventeenth-century Spanish statues symbolized the
dying curve of the old order. But the emergence of a new
order is also apparent, and its slow rise can be traced through
the gestures of a series of statues whose history spanned a
hundred years.

In an analysis of two statues of the Virgin and Child,
one by Gaspar del Aguila, the other by Diego de Robles,
there was a suggestion that stirrings of inner life and warmth,
though muted, were becoming progressively apparent, al-
though these classical statues remained immobilized within
their confining contours. In the subsequent decade, how-
ever, statues were no longer bound to this closed silhouette.
Three sculptures have been chosen to illustrate this pro-

gression (see page 144) and to make an explicit comparison between their silhouettes: Gaspar del Aguila's 1579 statue of the Virgin, the 1622 image of the Quitenian San Francisco, and Mena's 1675 carving of San Pedro Alcántara. The manner in which the closed silhouette slowly unfurls in this series can be likened to the organic process of growth and flowering.

PART II

6 *The Eighteenth Century*

Bourbon Spain

During the last quarter of the seventeenth century, there was a noticeable decline in all areas of Spanish life, in politics as well as in art. Wars, depopulation, a crisis in agriculture, a decline in manufacturing—all of these contributed to the waning of Spanish power. As the century came to an end, various European powers struggled to gain control of the Spanish throne. Ultimately, it was the French who were successful in championing Philip of Anjou; as King Philip V, he ruled Spain from 1700 to 1746. With his ascension to the throne, a close and continuing association with the French was established, which allowed Spain to benefit from the more modern administrative practices and experiences of her neighbor. Philip was succeeded by Ferdinand VI (1746–59) who, weak and intermittently mad, could not provide the country with strong leadership. Nevertheless, his reign was a peaceful one. Reforms initiated during this period bore fruit during the reign of his successor, Charles III (1759–88). Son of Philip V by his Italian second wife, Isabel Farnese, Charles first reigned over the Kingdom of the Two Sicilies from its capital, Naples. As king of Spain, he was to become the greatest monarch of modern times. Under his administration, sweeping reforms were realized in the social, political, and economic spheres. As a result, both Spain and her colonies enjoyed a period of prosperity. During his reign the currents of revolutionary thought engendered by the French and American

revolutions first made themselves felt. The monarchy was able to resist these currents, however, due to its strong and able policies. Charles III was succeeded by the ineffectual Charles IV (1788–1808). During this period, the French sought to influence Spanish politics, and their plots to take over Spain and Portugal grew increasingly bold. Eventually French pressures forced out Charles IV and then, after the briefest of reigns, the popular Ferdinand VII had to abdicate in 1808. This ushered in a period of great political change that coincided with Spain's loss of her overseas colonies and served as prelude for her eventual emergence as a modern European nation.

The Kingdom of Quito

Both contemporaneous historic documents and John Leddy Phelan's exhaustive study, *The Kingdom of Quito in the Seventeenth Century*, provide a picture of Quito and surrounding territory as that century drew to a close. Virtually isolated behind the barrier of the Andes, the fertile mountain valleys provided grazing for horses and mules as well as flocks of sheep whose numbers ran into the hundreds of thousands. Land ownership was concentrated in the hands of a small number of European colonists. A dense and docile population of Indians provided them with abundant cheap labor. The society was hierarchical and paternalistic, tradition bound, and attached to the ritual but seldom to the ethical spirit of Spanish Catholicism. One of the most imaginative of the Spanish authorities, Antonio de Morga, during his tenure as governor general of the Audiencia of Quito (1612–36), had waged a tenacious battle with the viceroys in Lima to secure more autonomy for the territory which he considered to be a separate political, geographical, and economic entity. His ideas served as prologue to the sense of national identity, which grew stronger throughout the eighteenth century.

As the century dawned, no intimation of the vast changes which would trouble its closing years was apparent. The legal archives of the period reveal the usual tragicomic human plight—fights over water rights, inheritances, and mothers-in-law, as well as a preponderance of drunkenness and sexual crimes. The steady round of life continued, punctuated by the comings and goings of Spanish officials. There were always delays in the infrequent mails and little refuge from the taxes demanded by a distant Crown. Early in the century the economy of the country was dormant. A year-long drought in 1723 was followed by a year of torrential rains. The resultant depression—businesses suffered

severely and the tax rolls were sharply reduced—may have marked the lowest point in the economic life of the century. Periodic plagues brought by travelers invaded Quito, and subsequent petitions for intercession were directed to the Virgen de Guápulo whose image was paraded through the city streets.

The volcano Cotopaxi erupted throughout the century. In 1737, flames rising from its crater ascended to a height of three thousand feet and, reflected back on the snows of its summit, burned a brilliant red. In 1743 the roarings of its eruption were heard two hundred leagues away. Another eruption occurred in November 1774 and an even more catastrophic one just before the end of the century in 1797. According to a contemporary account, by five in the morning Quito was engulfed in a cloud so dense it obscured the sun. By eight there was no more light than on a cloudy day. An hour later it was as dark as twilight and soon after that, quantities of ashes and earth began to fall on the town. The citizens of Quito, convinced that this was a sign of divine wrath, formed a series of penitential processions which wound prayerfully through the streets. More than one anxious soul must have fled the chaos to find shelter in the more comforting darkness of the confessional. There were numerous earthquakes as well—in 1755, 1757, and 1775—which destroyed many buildings and damaged many churches.

During the eighteenth century, European interest in the New World was growing, and as a result, the information available about its lands and peoples increased. Books such as the *Gazzetiere Americano*, published in 1763 and attributed to the Italian Jesuit Juan Domenigo Coletti, provided lively accounts of Quito's ambience and social customs. Jorge Juan and Antonio de Ulloa accompanied the French Geodesic Expedition which came to Quito in 1734. The account of their long stay, rendered secretly to the Spanish king, provided detailed information on the political administration and the economy. On the eve of independence, in 1804, Alexander von Humboldt visited the country. His journals included detailed observations of the topography, and the sketches of his collaborator, Aimée Bonpland, were among the first to include details of the local flora.

Although vast tracts of land were yet to be explored and territorial boundaries were vague, during this period a growing number of more accurate and detailed maps made their appearance. The western boundaries of the Quito Audiencia were fixed by the shores of the Pacific, though in

the vast, humid lowlands of the Amazon Basin there were no known frontiers. The territory extended as far south as the town of Zamora, and as far north as Pasto and Popayán, now part of Colombia. Only the highlands were densely populated. In 1748, Pedro Maldonado, governor of the Province of Esmeraldas, addressing a meeting of the Royal Geographic Society in London, described his country:

> ... The northern part of the Kingdom of Peru is wilder and less cultivated than you in Europe can imagine. The whole country consists of little more than those exalted vales, if we may call them so, which lie between the chief ridges of the Cordillera mountains. Here the principal cities of Quito and Cuenca lie, along with lesser ones, all of which are well populated with Spaniards and their descendants. Apart from these inhabited valleys, the rest of the land, little known to the Spaniards, is covered with immense forests and sparsely settled with Indians [translation mine].[11]

Despite the distance, an increasing number of travelers in the eighteenth century were willing to brave the journey to reach the shores of South America. Landing at Nombre de Dios, on the east coast of Panama, or at Cartagena, those bound for Quito had a choice of two overland routes. Crossing the isthmus by mule train, they could then sail down the west coast to Piura, Guayaquíl, or Lima. The alternative was to undertake the journey of approximately fifteen hundred miles along the Camino Real past the towns of Cali, Pasto, and Popayán. Never without risk, travel in the eighteenth century was guaranteed to be without comfort. *Dilatado y penossísimo*, sighed one weary traveler, "slow and agonizing."

Travelers coming from Cartagena customarily stopped for a two-week rest in Popayán. The hardest part of the journey still lay before them, for they had to cross a series of mountain ranges which succeed each other with the tenacity of a well-planned defense. The trail wound dizzily up to *páramo*, only to wind dizzily down again. Rivers were crossed on a *tavarita*, a small wooden platform suspended on rawhide ropes. Passengers, assured that the passage was perfectly safe, were nevertheless cautioned to stuff their ears with cotton against the noise of grinding boulders, and advised not to look down lest the sight of uprooted trees borne along the swift current paralyze them with fright. On and on, up and down wound the road until at last the travelers gained a broad and level valley carpeted with welcoming flowers which signaled their approach to the civilized comforts of Quito, second largest city in South America.

The City of Quito and Its People

Phelan estimated that the total population, around 750,000, of the Audiencia of Quito remained more or less stable throughout the colonial period.[12] In the cities, however, and noticeably in Quito, a steady growth in the population was apparent. According to some estimates, the number of Quito's inhabitants increased steadily in the eighteenth century from 35,000 to 60,000.

Several maps of the town appeared in the eighteenth century. They show it marked off in square blocks in accordance with governmental regulations. However, Quito's uneven terrain made both planning and construction difficult. The Jesuit Father Juan de Velasco (1727–1819) writes in his *Historia del Reino de Quito:*

With the exception of the center which is level, the town is built on uneven terrain and surrounded by small hills and knolls. The various streams which course down the slopes of Pichincha cross the city by means of hidden culverts or are diverted to the numerous fountains, some beautifully designed, which provide water for the town [translation mine].[13]

Velasco's description carries with it a note of nostalgia, for he is writing from exile in Italy, far from his cherished homeland. Fr. Coletti was less euphoric. He complained that only the streets immediately adjacent to the main plaza were paved with cobblestones, and that the others were not only impossibly steep, but often knee-deep in mud due to the frequent rains. An even more disgruntled traveler insisted that it rained no less than thirteen months a year.

The central plaza was the principal focus of the town. It was flanked by religious and secular offices, visible signs of authority, such as the audiencia, the cabildo (the town council), the military barracks, the cathedral, and the ecclesiastical palace. The Spanish did not build towns like those of the North American West—towns bisected by an arrow-straight Main Street from which beckoned a restless horizon. By contrast, the Spaniards built their solid towns around a central plaza, about which life continuously surged. This self-encircling characteristic finds an echo in the houses built around a central patio, in the barred cloisters of the religious orders, and also in the closed ranks of a stratified society.

Within the confines of the city, diverse ethnic groups were represented. The *blancos y ciudadanos,* the "white citizens," stood at the very top of the social hierarchy. This class was divided between *peninsulares,* those born in Spain, and *criollos,* individuals of Spanish blood born in the colony. The conquerors and early settlers had been given lands

by the Crown, and their descendants rapidly acquired more. These holdings, some of which were incredibly vast, formed the basis of enormous wealth. For occupations, the whites usually chose the military, served as employees of the Court, or joined the priesthood. Their society, in imitation of the distant Spanish Court, was full of ritual elegance and elegant ritual. Hostages to their own limited views, the upper classes eventually became locked in their privileges and prerogatives and, with exaggerated pride in their patrimony, took refuge in lives of almost total idleness. Playing cards, going to mass, and making love, says Phelan, were their major social activities.[14]

At the other end of the social scale, a docile, underprivileged class of Indians afforded the ruling class abundant labor to cultivate the fields, to work in the textile mills, and to staff the haciendas and the household—in short, to perform all the physical labor which provided the colonials with their material comfort and wealth. Though the Indians were the demographic majority, they lived on the margin of the social and political life of the country. They maintained their ancient allegiance to the land and to their own local agrarian community. Though converted to Catholicism, they continued to celebrate their traditional rites. Naturally courteous and gentle, they were also introverted, sad, submissive, and credulous. It has been said *cantan llorando*, "singing they weep," their mournful songs accompanied by the music of the ancient pre-Columbian flute, the *rondador*. Enslaved under the guise of various paternalistic systems, they were routinely defrauded of their lands. Life in the Andean highlands was disastrous for them, although not as devastating as in other areas of South America such as Bolivia, where the Indian poulation working in the mines was decimated. Rising complaints against their harsh lot erupted into the unsuccessful rebellion of 1780, led by an Indian, Tupac Amaru. The injustices they suffered were somewhat alleviated in the eighteenth century under the reforms of the Bourbon monarchy. Negro slaves were also brought to the colony, though their numbers in Quito and in the Ecuadorian highlands were never very large. Malleable and adjustable, they often achieved positions of trust in a white household or exercised positions of authority over the Indians.

The gulf which separated the white ruling class from the Indian and the Negro was partially bridged by intermarriage. *Mestizaje* began as soon as the Spanish conquistadores formed alliances with Indian women. The children of such alliances were called mestizos. In the eighteenth

century, the whites, Indians, and Negroes continued to intermarry and intermingle, thus producing a bewildering variety of ethnic mixtures with such picturesque names as coyote, zambo, and the like. However, it was the mestizos who emerged as the most significant class. Mestizo children were traditionally raised with their mother and suffered from the same social prejudice as that directed toward her. Frequently they aspired to the social standing of their white fathers and adopted their Spanish names.

Hijos del desprecio they have been called, "children of scorn." They were equal to all others in the sight of God, says Phelan, but not in the eyes of their fellow men.[15] The mestizo was seen by both whites and Indians as a reproach to racial purity, as a threat to their own cultural solidarity. The number of mestizos increased rapidly until by mid-eighteenth century they made up a third of the population of Quito. The city's commercial atmosphere offered them a ready outlet for their latent talents and their social aspirations. It was in the city that the mestizos made their most significant contributions.

The concept of the European city was introduced by the Spaniards, and this new pattern imposed on the relatively unpopulated expanses of the New World was to alter decisively the nature of its culture. The city was a geographical locality with clearly delineated boundaries. In contrast to the often irregular and meandering configurations of the village, the city was laid out in geometric squares with obedient precision. The sensory atmosphere within this urban environment was greatly heightened, its social, cultural, and ethnic interactions greatly intensified, its pace quickened. It was the seat of both sacred and secular authority; it was a marketplace, a melting pot. As time passed and the population grew, a sense of shared culture began to permeate all of its classes and all of its citizens. Distinct and separate parts began to coalesce into a unity, and the city became a whole with an identity of its own.

The Eighteenth Century

7 Quitenian Colonial Sculpture

The eighteenth century saw the emergence and the full
flowering of the Quitenian school of polychrome wood
sculpture. Although indebted to the forms and techniques
of the parent Andalucian sculpture, the Quitenian sculptors
nonetheless exhibited a style and spirit entirely their own.
On present available documentary evidence, this school
flourished for roughly ninety or a hundred years, from around
1730 until the first decades of the nineteenth century when
Ecuador achieved political independence from Spain. Dur-
ing that period, Quitenian sculpture exhibited all the sty-
listic characteristics of European art—the Baroque, the
Rococo, and the Neoclassical—although each was subtly
restated in a local idiom.

In Spanish sculpture the Baroque was characterized by
emotional and theatrical attitudes with an emphasis on the
strong diagonal line and a richness of surface texture broken
into many "painterly" planes. The Quitenian Baroque, by
comparison, depended for its effect on a slower, heavier line
and on a colorful polychromy to give the surfaces a luxu-
riant texture. As a style, the Baroque remained a force in
Quito until about the end of the eighteenth century. The
Rococo in Quito was similar to the European style. Sen-
timental, sweet, even cloying, its primary concerns were
decorative, its principal manifestations small carvings bril-
liantly gilded and polychromed. As a style, the Quitenian
Rococo reached its highest moments in the last quarter of
the eighteenth century. The Neoclassical, which succeeded

it, made relatively little impression in Quito. It was introduced around 1803 by the Spanish architect Antonio García, who directed the renovation of the Quito Cathedral. As a reaction to the overwhelming profusion and emotionality of the High Baroque, the Neoclassical sought to return to the principles of structural simplicity.

The techniques employed by the eighteenth-century Quitenian sculptors were all derived from European models. Polychromy of the type initiated by Alonso Cano around 1630 was the most popular technique. No longer was the gold-based *estofado* used, but the statue, once it was primed, was directly painted with oils, as if it were a canvas. Also in use was *estofado a la chinesca* or *corlas,* which gained currency in the last quarter of the century. Quitenian polychromy was one of the glories of colonial sculpture. Its emphasis was on bright primary colors and floral designs. At first inspired in motifs taken from European engravings, these designs turned at the end of the century toward freer invention based on closely observed natural detail. Since many Quitenian sculptures were of the *de vestir* type, a highly polished *encarnación* was preferred, to which increasingly colorful details—reddened cheeks and bluish beards—were added, although the same characteristics were apparent in fully carved statues as well. Face masks made of lead, *mascarillas de plomo,* were also employed.

Vast stands of native red cedar, which covered the mountainsides near Quito, provided the raw material for many statues and retablos. A number of small figurines and a few larger processional images were carved of balsa wood. Other native woods such as *platuquero* and *aliso* may also have been used—it is hoped that scientific studies will some day clarify this question. According to some of Quito's present-day master carpenters, ancient practices were once observed: trees were always cut on the night of a full moon so that the sap which had risen would remain to strengthen the cut wood. Perhaps some of these secrets will also one day come to light. Much has yet to be learned as to the paints and tools employed in sculpture, and it can only be assumed for the moment that in the early years these were all imported from Europe, but that later some were locally produced.

The colonial artist worked within the guild system as had his Spanish counterpart. Regulations governing these organizations were introduced to the colonies as early as 1552 and in subsequent years were amended and amplified. The guilds closely controlled the graduated system of apprenticeship and the conditions under which an artist, once

he had passed the requisite examinations and amassed sufficient capital, could establish his own business; in the colonies these regulations must have been less rigidly enforced than in Spain. In the colonies the master sculptor did not belong to a cultural elite, a luxury which the colonies could not yet afford, although the practice of his art did accord him both a measure of social recognition and economic advancement.

The historian of the Mercedarian Order, Joël Monroy, indicates that the Quitenian guilds were established in Quito around 1560 and organized into *cofradías,* religious lay brotherhoods, around 1660 under the guidance of the Mercedarian Fr. Andrés Solá. However, specific mention of the guild of *pintores y encarnadores* does not appear in the annals of the town council until 1741. The first mention of the guild of *escultores y doradores* appears a year later in 1742. These dates suggest that the sculptor now chose to exercise his profession independently of the Catholic Church, which was formerly his chief patron. This tendency toward artistic emancipation culminated toward the end of the century in the complete dominance of the free enterprise system.

In 1746, the words *"abrir tiendas,"* to open a shop, appear in these same archives indicating the emergence of free enterprise in establishment of small businesses. The number of guilds listed and the great diversity of their specialties indicate the growing importance of the consumer society.

Herradores, Latoneros, Botoneros, Coheteros, Canterones, Zapateros, Curtidores, Tejedores, Rengueros, Damasqueros, Espaderos, Calzateros, Borneros, Cafeteros, Landerneros, Sombrereros, Ebanistas, Tintoreros, Prensadores, Bordadores, Floreros y Fijadores, Galoneros, Guitarreros, Arperos y Rebeleros, Peluqueros.[16]

This list includes hatters, lampmakers, weavers, florists, button makers, coffee grinders, and guitar and harp makers, to name but a few. This vigorous manifestation of free enterprise was the direct result of the reforms instituted by the Bourbon monarchy and presaged the decline of the guilds. By 1782, painters, sculptors, and architects were legally authorized to work independently of the guilds. In 1783, the *cofradías* attached to these guilds were suppressed. By 1790, a recognized artist could work without having to pass any examination, and three years later for all practical purposes the guild system was dissolved.

Concurrently, restrictions governing both internal and external trade had been eased and finally abolished under

the great Edict of Free Trade of 1778. After that date, all ports of Spain were permitted to trade directly with the colonies, and intercolonial commerce was encouraged. Haring says that the increasing freedom of commercial movement within the colonies in the second half of the eighteenth century did more than produce a greater volume of business. As a result prices were reduced, contraband trade was discouraged and a wider distribution of wealth was effected.[17] The Quitenian sculptor, no longer under the dominance of church patronage, turned to the secular marketplace. A number of workshops, each with a recognizable and individual style, sprang up, and the artist turned increasingly to the production of items freely made and freely sold. Quitenian sculptures found their way throughout South America—to Colombia, to Lima, to Rio de la Plata—and no fewer than 254 cases of sculpture were shipped to Europe from the Port of Guayaquíl in the years 1779 to 1787.

In the early days of the colony the newly formed guilds must have included some of the artisans who emigrated to the New World. In time, however, the whites came to disdain any form of manual labor, and the ranks of the guilds were filled with the lower classes. It was mestizos, says Haring, who acted as journeymen in the guilds.[18] Contemporary accounts report that the mestizos engaged in commerce and in the practice of the arts, choosing painting and sculpture—the most prestigious—in which they excelled. The increasing number of skilled Quitenian artisans provided the foundation for the emergence of the individual artist. The eighteenth century witnessed the transformation of the artisan into the artist and the emergence of the mestizo as a brilliant sculptor.

The panorama of Quitenian colonial sculpture is one of almost total anonymity. While it is true that seventeenth-century documents occasionally mention the name of this or that sculptor as having been paid a certain sum to carve an icon, more likely than not these references were not to professionals but to unschooled artisans trained as wood carvers. The names of certain sculptors such as Pampite, Gregorio, Francisco Tipán, and Sor Magdalena Dávalos are known; however, little of their work has been identified. The two best-known names are those of the mestizos Bernardo Legarda and Manuel Chilí, called Caspicara.

It is common practice to attribute statues to one or the other of these famous artists, often without sufficient basis. The purpose of this present study, however, is not to attribute individual works of art to Quitenian sculptors, but rather to present the general stylistic currents of Quitenian

colonial scupture in the period 1730–1830. For the purposes of this study, Bernardo Legarda can be seen as the representative of the Baroque style and Manuel Chilí as embodying the Rococo, the two principal stylistic categories for eighteenth-century Quitenian sculpture. During this epoch the sense of Quitenian identity grew toward maturity. The artist is one of the first to anticipate intuitively such a coming change in attitude. In this the Quitenian artist was no exception, and in response to a subtle change in the cultural climate, he reinvigorated the old prototypes with a new spirit and sought new forms in order to provide the emerging nation with visible symbols of itself. However, the true artist cannot illustrate a process from which he is fundamentally dissociated; rather, for such an expression to be valid it must coincide with his own deepest experiences as an artist and as a free individual.

The Jesuits

In Europe the Jesuits had emerged as the principal champions of the Counter-Reformation, and the Order was most responsible for the revitalization of Catholicism. In the Kingdom of Quito, their policies and philosophy contributed significantly to the change in the intellectual and commercial climate in the eighteenth century. They thrived when other religious orders, having lost their original fervor, were in decline. The Jesuits' espousal of Christian humanism led them to foster an atmosphere of intellectual curiosity and vitality. In the colonies they established secondary schools, universities, and libraries; Coletti estimated that their Quito library contained no fewer than 4,000 volumes. They brought the first small printing press to the capital in the early part of the century and were among the first to disseminate the ideas of the French Encyclopedists and other contemporary European philosophers. The Jesuits encouraged an interest in geography, natural history, historical studies, and other branches of science; many of their own members, such as the poet Aguirre and the historian Velasco, made distinguished contributions in various fields. Jesuit influence, profound and long-lasting, survived even after the Order was expelled from all the colonies in 1776 for complex political reasons.

In Rome the Jesuits had seized on the Baroque style as an appropriate expression of the vigor and scope of their own ideas. In Quito two important Baroque sculptures are

indebted to designs which the Italian Jesuit Fr. Andrea Pozzo (1642–1709), one of the principal artists of the High Baroque, executed for the churches of Sant'Ignazio and Il Gesú, both in Rome. The Quitenian statues, one of Saint Ignatius Loyola and the other of Saint Francis Xavier, stand in altars at either end of the transept in the Jesuit Church of La Compañía.

Pozzo's masterpiece is considered to be the painting on the interior dome of the church of Sant'Ignazio in Rome, built to honor the founder of the Order. The painting represented the missionary work of the Jesuits and the apotheosis of Saint Ignatius of Loyola in a vast, complex allegory placed in a vortex of soaring space and vanishing perspectives. While nothing so ambitious was attempted in the New World, other designs of Pozzo's were transmitted to the colonies by means of engravings. According to the historian Santiago Sebastián:

The influence of the Jesuit father, Andrea Pozzo, was received basically by means of his treatise, *Prospettiva dei Pittori e Architteti* (Roma 1700), and is manifested principally in the altars of the main chapel and those at the crossing of the very famous church of La Compañía in Quito. The altar of Francis Xavier (at the crossing) is almost an exact copy of that of Luis Gonzaga in the Roman church of Saint Ignatius, which Pozzo produced in Figure 26 of the second volume of his book [translation mine].[19]

The design for the figure of San Ignacio was inspired by a silver statue executed by Pierre Legros (1656–1719) in 1699; the Parisian-born artist worked for many years in Italy and based his statue on a design by Pozzo for the Roman church of Il Gesú. This design was disseminated by means of an engraving and became a standard representation.

Plate 7

The entire composition of the altars functions as an elaborate device to frame the central figure. These Quitenian altars in La Compañía are attributed by Father Vargas, one of Quito's leading archivists, to the Austrian Jesuit Jorge Vintener. According to documents in the Jesuit archives, he was called to Quito in 1743 to design and execute the main altar of the church as well as several others, referring probably to these side altars. By extension he is also credited with the figures which stand in them. The carving of these statues, however, does not seem European but Ecuadorian. Comparison of the Quitenian San Francisco Javier with a contemporary Spanish image would reveal a much clearer articulation of the features in the European example. In the colonial image the face is full, soft, and bland; there is less sense of the underlying structure. Ignorance of anatomical details and proportions is a persist-

Figure 24

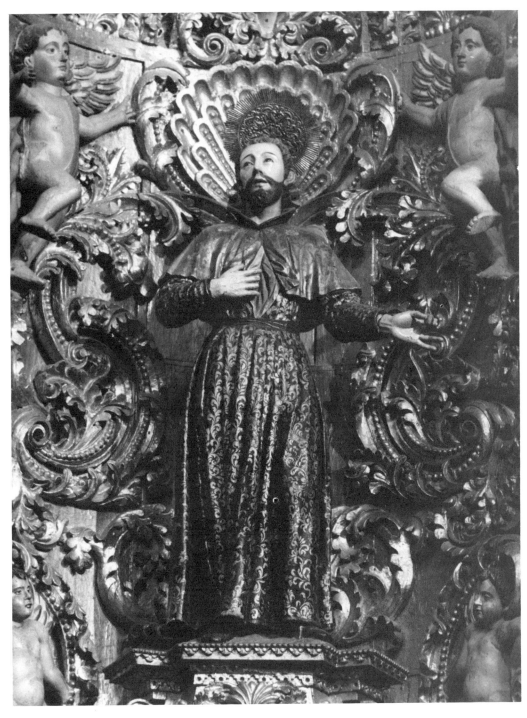

24. *San Francisco Javier*, c. 1743. Church of La Compañía, Quito. Foto Wuth.

Quitenian Baroque Sculpture

73

ent feature of colonial sculpture. The small red cylinder the saint holds in his hand is a decorative detail which also appears often in Ecuadorian colonial sculpture. Its meaning and origin are unknown although it may have been inspired by a Spanish custom; images of the Virgin Mary occasionally held a small receptacle for flowers in one hand.

The statue of Saint Ignatius is carved in a naturalistic manner. The folds of the drapery fall simply, clinging partially to the body to reveal its movement, while the broad expanse of the chasuble relates the image to its architectural setting. The concave surface of the niche in which the image is enclosed is entirely covered with carvings. Cast into high relief with each shifting light, these mold and enliven the intervening empty space and provide a sense of motion and vitality. The raised arms of the figure are fully extended and form a vigorous diagonal.

The drawings of three statues previously shown (see page 144), have suggested how the closed silhouette gave way to a more open one during the Spanish period (1580–1680). If a schematic drawing of Saint Ignatius is added it can be seen how the last statue completes the series as the collective gesture reaches its fullest extension. In addition, a comparison of the type of constricted niche which may have held the Virgin and Child with the large semicircular enclosure of Saint Ignatius, reinforces the sense of increased freedom (see page 147).

The bold upward and outward thrust characteristic of the European High Baroque will be seized upon by colonial sculptors in the Baroque period. However, the sculptor of the Quitenian Baroque does not merely absorb and restate the stylistic conventions of the European Baroque at a superficial level, nor does he simply modify them to conform to his own local environment in the expression of a purely local style. Rather the significant artist, functioning at a much deeper archetypal level, appropriates these Baroque attitudes specifically because they correspond to the thrust of his own emerging self-expression. They provide him with exactly the form he needs to express ideas already latent in both the collective and individual unconscious of his society. The same principle applies to the selection of subject matter. The Quitenian sculptor (here again the distinction must be made between the derivative artist and the more independent and responsive one) chooses among the available themes those which most closely correspond to the processes of the unconscious, and which most aptly evoke a particular moment in its evolution.

Engravings

The use of engravings for designs of the altars in La Compañía emphasizes their importance in the art of the colonies. The colonial architect had relied on European engravings when drawing up plans for constructions. The *ensamblador* had also consulted them in his designs for altars and in the elaboration for their decorative motifs. For the colonial painter, they were the wellspring of his inspiration. In the eighteenth century, engravings provided the single most significant source of design for the Quitenian sculptor.

In Spain, engravings had been commonly used by seventeenth-century sculptors. Says Beatrice Gilman Proske:

Drawings and engravings were an artist's source for composition when his own inspiration failed him. Both Italian and Flemish engravings were popular . . . Pacheco, Jerónimo Hernández, Andrés de Ocampo and other contemporary sculptors all had numbers of engravings.[20]

In Quito as well, engravings played a major role in colonial sculpture. Italian, Flemish, French, and Spanish engravings, in addition to woodcuts and paintings, provided the principal new artistic source for the Quitenian sculptor. Although seventeenth-century Spanish sculpture continued to provide the newly emerging Quitenian sculptor with ready prototypes, he turned increasingly to these two-dimensional print sources which significantly enlarged his repertory. The transference of idea and design from one medium to another provided the Quitenian artist with the psychological freedom to exercise his own originality.

When the sculptor chooses an engraving for a prototype, he, in effect, succeeds in translating a small, two-dimensional, black-and-white image printed on a page into a large, brilliantly colored three-dimensional sculpture. This work of art is in every sense "fuller" than the design from which it derived its immediate inspiration. It can only be some aspect of the artist's own selfhood which supplies the more ample measure, his own vitality which he transfers to his own creations.

Bernardo Legarda and His School

The Quitenian Baroque style of sculpture begins with the work of Bernardo Legarda, and in his work we see the first positive assertion of an individual Quitenian artist. The Jesuit historian Juan de Velasco (1727–92) praised Legarda as a man of extraordinary talents. A painter, sculptor, and architect, he managed a large and successful workshop

near the monastery of San Francisco. In his will, dated 1773, the wide range of his activities is revealed. In addition to woodworking, he also carved ivory, cut mirrors, made frames, repaired weapons, and kept a small press for printing engravings. Various documentary references to Legarda's work indicate a period of activity from 1731 to 1762, and reveal that he worked in most of Quito's major churches—San Francisco, Cantuña, La Merced, Santo Domingo, and the Sagrario. He executed many altars in the tradition of the Spanish *ensamblador.*

Carved wooden altar screens had always been considered important works of art in Spain. Martínez Montañés, Alonso Cano, and others had designed and executed some of the numerous retablos which line the walls of the churches in Sevilla and other towns in Andalucia. In the Baroque period, José Churiguerra (1665–1725), ably assisted by a numerous family, had developed the *entallador* style— enormous altar screens supported by monumental sculpture and covered with decorations in high relief. In Quito, Legarda was influenced by this general current, although his own style was less exuberant than Churiguerra's. While Legarda's fame may eventually rest on his work as designer of retablos, at present he is chiefly renowned as the man

Plate 9

Plate 10

who, in 1734, carved *La Virgen de Quito.* This work is one of the city's most venerated religious images and now occupies the central niche in the high altar in the church of San Francisco.

La Virgen de Quito is based on an iconographic type known as the Apocalyptic Virgin and is inspired by a passage in the Book of Revelations. It is a variation of the earlier portrayal of the Immaculate Conception which had origins in the popular belief, later officially accepted as dogma, that Mary was born free of "original sin" and thus able to redeem the transgression of Eve. By contrast with earlier, more passive images of the Immaculate Conception, the Apocalyptic Virgin is a vivid and dynamic portrayal. The Virgin, winged and crowned with stars, crushes the serpent of evil underfoot. Engravings of both the Immaculate Conception and of the Apocalyptic Virgin were widely circulated in the Spanish colonies and served as sources for sculptures such as this one.

Legarda's carving of the Virgin is one of the first historically documented Quitenian colonial sculptures. It marks a psychological milestone for the colonials as well as an artistic one, since the Virgin was given a local identity as patroness of the Franciscan Order. The figure is simply and boldly carved. Although some of the anatomical propor-

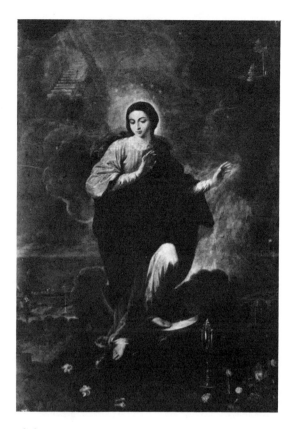

25. Miguel de Santiago. *Inmaculada Concepción*, early
eighteenth century. Convent of San Augustín, Quito. Foto
Wuth.

tions are rather awkward, it speaks of inner vitality and of
substance. In marked contrast to earlier Spanish statues,
the axis of this figure is disposed in a slow curve. The
mantle which encircles the body provides a sense of move-
ment and a more pronounced three-dimensionality, al-
though the figure still exhibits certain frontal qualities
which link it to its architectural setting. The pose is iden-
tical to one which the Quitenian painter Miguel de Santiago *Figure 25*
used for his rendition of the Immaculate Conception. But
the carving expresses a more robust, less reticent spirit, and
the addition of silver wings designates an apocalyptic Virgin.

The gaze of the Virgin turns triumphantly upward on *Plate 8*
a high relief carving of the Assumption of the Virgin, which
also bears the imprint of the Legarda style. Based on a very
common and widely circulated type of engraving, this Ecua- *Figure 26*
dorian carving is rendered with real verve. The diagonal of
the arms and the tilt of the head belong to the traditional

77

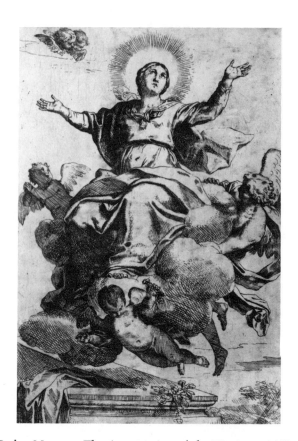

26. Carlos Maratta. *The Assumption of the Virgin*, c. 1660. Engraving. Photo Museo de Arte Moderno, Barcelona, Spain.

Baroque vocabulary. But the delicate gesture of the hands, the energetic zig-zag profile of the edge of the mantle outlined in gold, and above all the design of the pedestal depart from European tradition. The base, which in Europe would have been composed of sweet gamboling cherubs, is here reduced to a bold and original element—the head of a single angel flanked by huge wings—which provides the statue with a powerful outward thrust.

The face and neck of this sculpture are not carved of wood. Instead, a molded mask has been affixed to the head of the statue and painted in flesh-like tones. In his will, Legarda speaks of a *batea para moldar*, a vessel for making lead molds. This was a common practice in Baroque times—to make face masks of lead or tin and fasten them to the carved head of a statue. Legarda would have carved the original from which a master mold was made and copies such as this one later cast in a series.

The face and tilt of the head are similar in another carving of the Immaculate Conception, indicating that it,

Figure 27

too, may have issued from Legarda's workshop. In this example, the Baroque diagonal line has been exchanged for a resolute and powerful symmetry. The figure emerges from its huge half-moon pedestal as solidly as the living tree from which it was carved must once have grown from the forest floor. The mantle, disposed into two stiff little wings, suggests that this robust carving may actually have been intended to represent the upward flight of the Virgin in her assumption to heaven. The polychromy is lavish. The white gown is decorated with a pattern of roses interspersed with gold designs. The stylized manner in which the edge of the drapery falls to the floor in a series of complex folds recalls the earlier Spanish carvings of Montañés and Cano. The design of the base—the angel's head in this case dwarfed by enormous clouds—is high-spirited; it speaks of the resurgence of a primitive vitality and is a Quitenian expression. All three of these images have caught the powerful thrust of the Baroque. The addition of the brilliant Quitenian polychromy adds a note of even greater vigor.

Another image of the Immaculate Conception, although it expresses the same aesthetic sensibilities as the Legarda statues, introduces a more delicate, feminine note and may well be the work of an unknown contemporary of Legarda. It is based on an engraving similar to the one used by Miguel de Santiago for his painting of the Immaculate Conception. The lowered gaze gives the image a reticent air. But the figure is carved fully in the round and the effect of three-dimensionality is underscored by the mantle which completely encircles the figure. A design motif in the shape of a crescent is established by the position of the hands and repeated in both the curve of the drapery and the pedestal. The rhythmic descending cadence transforms this into a pervasively musical image.

Similar delicacy is apparent in a statue of Santa Rosa de Lima (c. 1770–80), which marks a high moment in the history of Quitenian colonial sculpture. Santa Rosa (1586–1617), born and raised in Lima, Peru, was famed for her physical beauty as well as for her profoundly mystical nature. The Counter-Reformation in southern Spain was closely interwoven with mysticism and with the teachings of such saints as Santa Teresa de Avila. Santa Rosa was inspired by her example. A member of the Dominican Order, she was canonized in 1671, the first American saint to be so honored, and was named Patroness of all the Indies.

Figure 28

Plate 11

Quitenian
Baroque Sculpture

Text continues on page 82

79

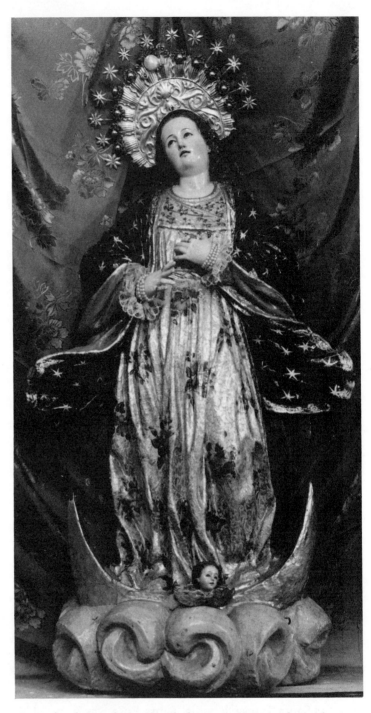

27. Circle of Legarda. *Inmaculada Concepción*, eighteenth century. Private Collection, Quito. Foto Wuth.

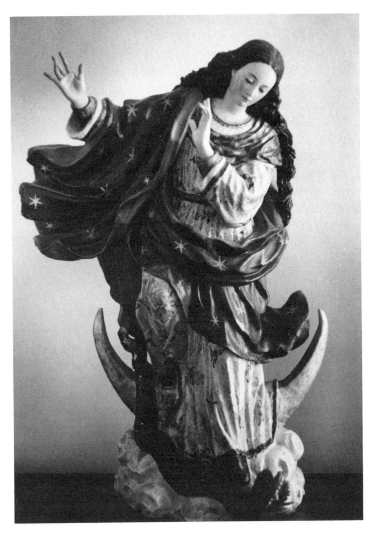

28. Circle of Legarda. *Inmaculada Concepción*, eighteenth
century. Private Collection, Quito. Foto Hirtz.

Often portrayed beautifully in European paintings, Santa Rosa was venerated not only in Peru but throughout the Hispanic world. The iconographic representations of the saint most commonly employed in Spanish America were based on European engravings. This Quitenian sculpture, however, does not conform to any engraving yet brought to light; rather it follows one of the standard Baroque conventions, that of showing a saint holding the Infant Jesus. Stylistically, however, it represents the transition from the Baroque to the Rococo. The figure of the Child Jesus which Santa Rosa cradles in her arms was copied from an Italian ivory carving brought to Quito from Rome in 1689 by a Dominican, Fr. Ignacio Quesada.

Figure 29

The originality of the Quitenian carving does not lie in its iconography but in the design of its drapery. Less a carved statue than a representation of motion in space, the figure is completely enveloped in flying draperies of *tela encolada.* This technique originated in Europe but was never so boldly employed there. Its expressive use in this Quitenian statue serves to remind us that the local, native-born artist was increasingly original and capable of developing his own style. Santa Rosa's habit is painted in silver and decorated with a pattern of scattered roses. When light catches and traces the edges of the darker cape, the whole statue resembles the flower from which the saint took her name. It is interesting to note that in the Quitenian Baroque the most imaginative portrayals were those of the Virgin Mary or of female saints, in contrast to the Spanish period when the emphasis was on male saints. And whereas the straight line predominated in seventeenth century, in the Quitenian Baroque the curved line was emphasized. This can be seen in schematic drawings of *La Virgen de Quito, La Inmaculada Concepcion,* and *Santa Rosa* (see page 145).

A further transition can be discerned in several Baroque statues. The Saint Ignatius, representative of the European High Baroque, seemed to be trying to reach beyond the edge of the niche in which he is standing. By contrast, the figure of Santa Rosa, signifying the transition between the Quitenian High Baroque and the Rococo, is freed from any frame and appears to stand under an open sky (see page 147).

Francisco Salzillo

While the presence of Spanish sculpture was overwhelming in Quito in the seventeenth century, the eighteenth century showed little noticeable direct Spanish influence on the indigenous art of Quito. One possible ex-

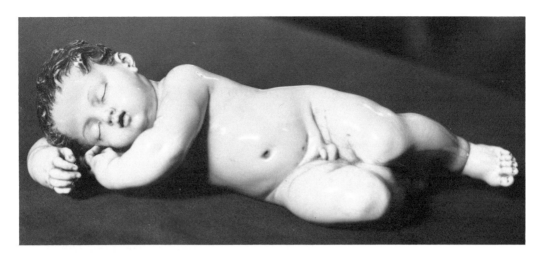

29. *Niño Jesús*, seventeenth century. Italian ivory carving.
Museum of the Convent of Santo Domingo, Quito.
Photo G. Palmer.

ception worth noting was the work of Francisco Salzillo
(1707–83), one of the few sculptors to achieve fame in Spain
in this period. Of Neapolitan origin, Salzillo lived in Mur-
cia, Spain, on the Mediterranean coast; today there is a
museum in Murcia dedicated to his work. The earliest ref-
erence to him appears in 1729, though he reached the peak
of his career between 1748 and 1767, when he perfected
his style of spirited, sentimental realism. During this period
he directed a sizeable workshop and was surrounded with
disciples, the most famous of whom was Roque López.
Salzillo carved statues of San Pedro Alcántara and the pen-
itent Saint Jerome, of the Guardian Angel, and the Virgen
Dolorosa, as well as groups of figures in the traditions of
the Holy Week *pasos,* all of which were in essence exten-
sions of earlier seventeenth-century Baroque prototypes.

Though engravings and woodcuts served Salzillo as
sources of inspiration, he also drew from real life. Friends
and members of his family served as models, providing
some of his creations with individual portrait character-
istics. He expanded the repertory of the nativity scene to
include such themes as the Annunciation, the Visitation,
the Dream of Saint Joseph, and the more traditional rep-
resentations of the Magi, the Flight into Egypt, and the
Massacre of the Innocents. He is most famous for large
tableaux vivants such as the Last Supper, composed of
many life-size figures. Salzillo's work exemplifies all of
the significant trends of Baroque sculpture in the eight-
eenth century with its emphasis on the close interrela-
tionships between sculpture and theater, and the portrayal

*Quitenian
Baroque Sculpture*

of images in which he sought to capture the subtler psychological aspects of personality. None of his works appears to have reached Quito, although the general style which he exemplified and the themes he employed were reflected in Quitenian sculpture.

There are several *pasos* in the museum of the monastery of San Francisco in Quito which represent the Prayer in the Garden, the Kiss of Judas, and the Denial of Peter. These may be the earliest examples of this type of image, illustrative of biblical events, which were intended to be taken in procession during various religious ceremonies. Two other groups bear a closer relationship to Salzillo's tradition of large figural groups. One of these is a group of the Twelve Apostles, commissioned in 1789, which has been placed on the high altar in the church of San Francisco. Intended as a dramatic and literal representation of the Ascension, the group originally included a figure of Christ which was, at the culmination of the ceremony, raised into "heaven" by mechanical means. One day the mechanism failed, and the statue of Christ fell and was irreparably damaged. The Twelve Apostles remain to this day, gesticulating and gazing upward in awe. Each is portrayed in a realistic manner. Their robes are polychromed in colorful designs, but the mantles are plainly painted. One of the apostles stands with hands clasped to one side, gazing after the vanished Christ.

Figure 30

The second group, representing the Dormition of the Virgin, is more artistically interesting though it is seldom seen since it belongs to a cloistered order. This theme, which appears in art as early as Byzantine times, is a visual interpretation of the legend which relates that the Virgin, having been granted her wish to join Christ in Paradise, dies surrounded by the apostles. Engravings of this subject served as a basis for numerous contemporary Quitenian paintings of the period, although representations in sculpture are rare, and this group is unique in the annals of colonial sculpture.

Plate 13

Dramatically lit by an overhead skylight, the group has been placed in a room in the convent reserved for this purpose. The Virgin, dressed in a brocade gown, lies moribund in an elaborately carved Rococo bed. She is surrounded by angels, the two Marys, and the Twelve Apostles. It is apparent that two different sculptors have fashioned the figures of the apostles. Time has erased the legends at the base of each statue which would have made it possible to identify them. One of these carvings is skillfully executed although its design appears to incorporate two con-

Figure 31

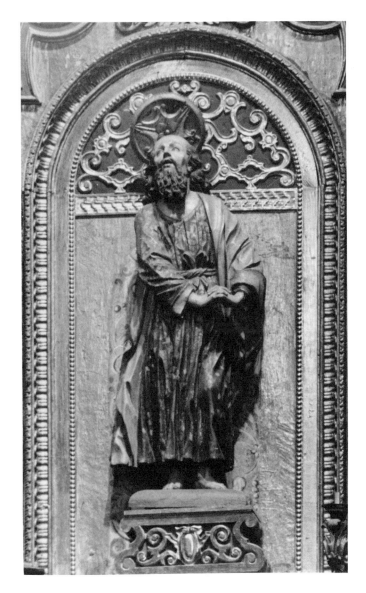

30. *Apóstoles*, late eighteenth century. Main altar, Church of San Francisco, Quito. Foto Wuth.

flicting currents. The ecstatic upturned face is a conventional Baroque signature, while the body, with the arms close to the side, exhibits a more classical closed silhouette. The polychromy is more sober, a simple gold pattern on a dark ground. A companion sculpture is the work of a craftsman who is, in some respects, less accomplished. The length of the robe is awkward, and the feet huge and clumsy, although it may well be that the statue was partially carved by an apprentice or helper. By contrast, the face of the image is carefully executed and conveys a sense of eloquent sin-

Figure 32

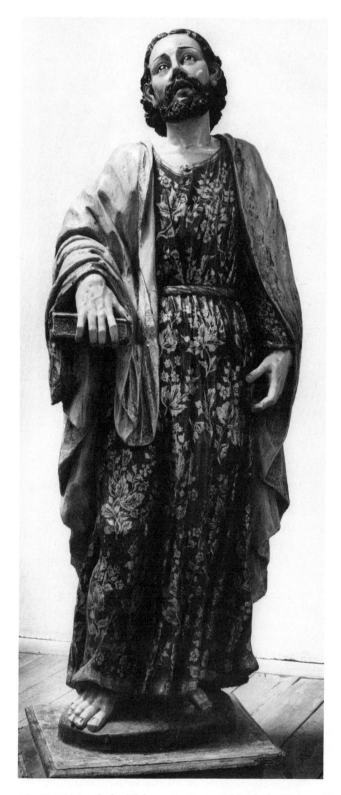

31. *Un Apóstol,* detail from La Dormición de la Virgen. Foto Hirtz.

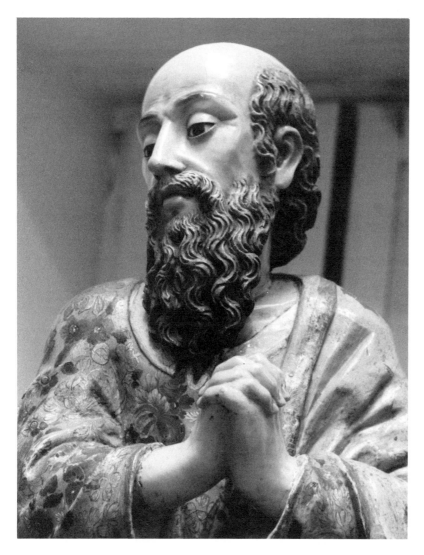

32. *Un Apóstol,* detail from La Dormición de la Virgen. Photo
G. Palmer.

cerity. Its sculptor had a strong sense of design, particularly
evident in the treatment of the beard. The work is a telling
representation not only of piety but of tangible humanity.
In Europe, the Baroque was the great age of portraiture. In
Quito the only portraits were those of officials. However,
in this statue an analogous trend can be discerned. There
is a subtle turn away from the portrayal of a saint as a
generic type and toward a portrayal of individuality. A sim-
ilar piety is shown in the kneeling apostle; the design and
sharp carved edges of the drapery relate this image to the
apostle in the church of San Francisco, suggesting that the
same workshop may have been responsible for both groups.

Plate 14

Salzillo also carved *de vestir* images of the Ecce Homo and of the Virgen Dolorosa. This type of sculpture had become increasingly popular throughout Spain in the eighteenth century. It also became the vogue in the colonies.

Figure 33

One Quitenian image of the Ecce Homo in the church of Cantuña belongs to this tradition, although its facial characteristics suggest a native Ecuadorian. The expression on Christ's face is one of mute pain. His mouth is choked with blood, and a great bruise disfigures his left cheek. The hands, though clumsily carved, convey a sense of painful paralysis, and the fingers are painted a moribund greenish gray. While it is difficult to date such *de vestir* images, the emphasis on literalism helps to place this carving in the late eighteenth century. By portraying Christ with indigenous features, the mestizo sculptor may be obliquely identifying Christ's sufferings with those of his own people.

The Franciscan church of Cantuña is one of the architectural gems of Quito. A small single nave church, it boasts a highly decorative main altar. No longer divided into tiers and niches, the central focus of this altar is the central niche which has been expanded into a small stage.

Figure 34

On this stage can be seen the figure of the Crucified Christ mourned by the Virgin Mary, the kneeling Mary Magdalene, and Saint John the Evangelist. Such groups were repeated countless times in colonial sculpture. The iconography was standard and the gestures and expressions were stereotyped.

Plate 12

The Quitenian statue, *María Magdalena*, from the Cantuña main altar, is typical with its upturned face, parted lips, its imploring and pathetic expression.

Numerous carvings of the Crucified Christ are found throughout Quito. Many such carvings were copies of earlier Spanish models. A few were endowed with an original

Figure 35

spirit, such as the poignant portrayal here illustrated. Another image which transcends the stereotype is one of the

Figure 36

Virgen Dolorosa. Justly famous, this carving is traditionally attributed to the Quitenian sculptor Caspicara. A small and rather simple image, it is crowned with a huge silver aureole. The emotional impact lies in its reserve and in the expressive gesture of the hands which provide a contrast to the somber richness of the heavily embroidered dress.

In an increasingly wealthy society, dress was one of the principal means of ostentation. Members of the upper class wore taffeta, fine lace, and china silk. Not to be outdone, venerated religious images also boasted elaborate and costly wardrobes, and wore rings, brooches, bracelets, and

Chapter Eight

Text continues on page 93

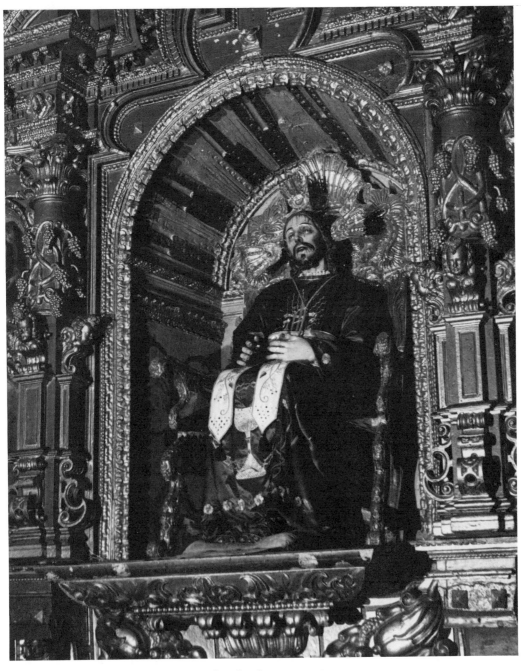

33. *Ecce Homo*, eighteenth century. Church of Cantuña, Quito.
Photo G. Palmer.

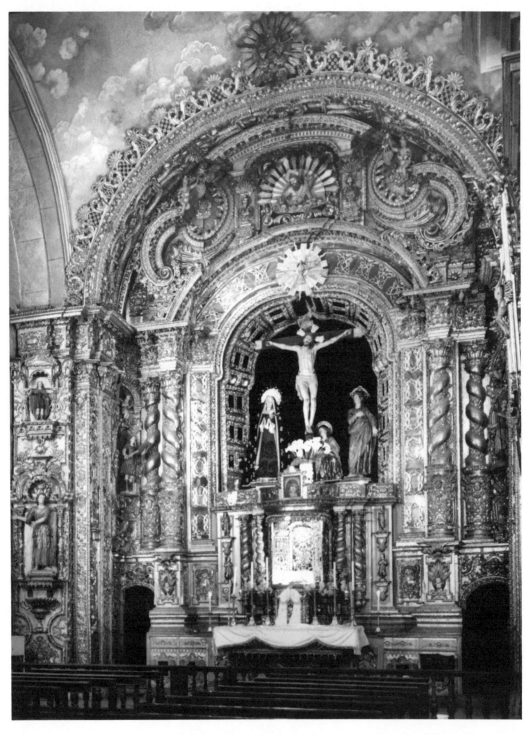

34. *Altar Major*, eighteenth century. Church of Cantuña, Quito. Foto Hirtz.

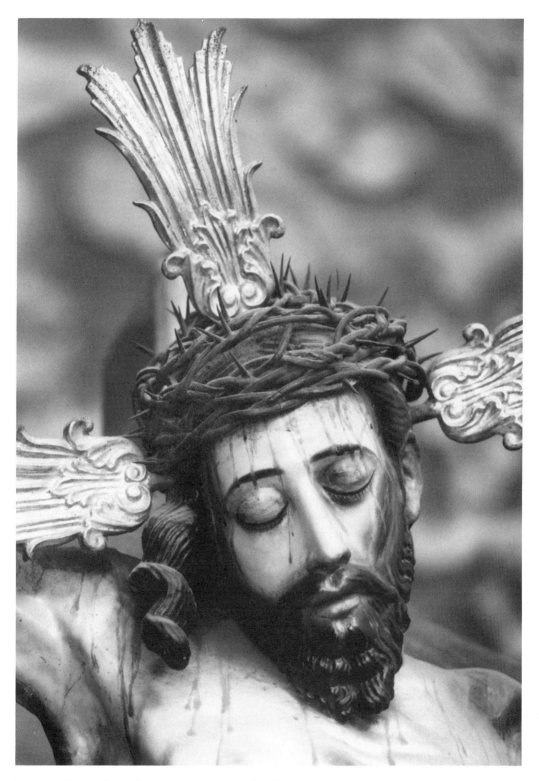

35. *Crucifijo*, eighteenth century. Private collection, Quito.
Foto Hirtz.

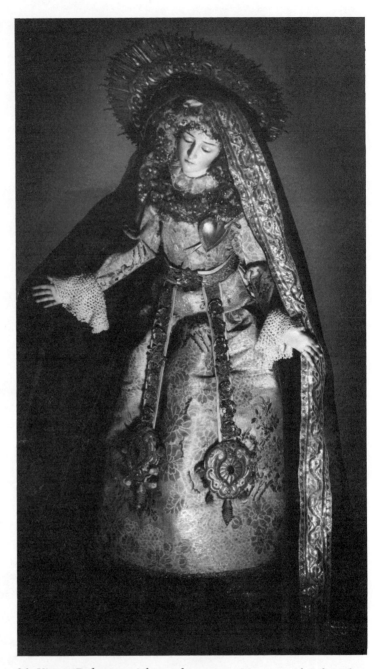

36. *Virgen Dolorosa*, eighteenth century. Museum of Colonial Art, Quito. Foto Hirtz.

even sandals studded with precious stones. As secular wealth increased, so did the wealth of the religious orders. The sumptuous aspects of religious sculpture became ever more pronounced. The clergy dressed in gorgeous vestments, and monstrances glittered under a burden of diamonds and emeralds. The Jesuit Fr. Coletti told of the magnificent decoration in the churches and convents, particularly on the occasion of religious festivals when the pageantry of the church overflowed into the streets. The occasions for religious processions were frequent, and the whole town participated. The streets along which they passed were decorated with triumphal arches and magnificent altars. The processions included civic officials dressed in Roman togas, the archbishop in full ecclesiastical regalia, members of the guilds mounted on caparisoned horses, and then, in carefully designated order, the humbler folk of the town.

The Church had originally played the most significant role in the consolidation of the colonies. It was the most imaginative institution, claims the historian German Arciniegas, and performed many of the functions reserved in modern times for the state, such as the establishment of charitable, medical, and educational institutions. During the eighteenth century, however, the accumulation of enormous wealth by the Church and the various religious orders brought corruption in its train. In Quito, a number of religious orders were touched with scandal and the laxity was pronounced. In the course of colonial history, says historian Clarence Haring, the Church had passed from evangelical fervor to corrupt refinement.[21]

With the deterioration of the Church came a loss of religious ardor; this was reflected in the change in form and content of Quitenian sculpture as the Baroque style gave way to the Rococo. The advent of the Rococo signaled a growing concern with secular themes. Artists turned from what had been the exclusive patronage of the Church and offered their works for sale in the open marketplace. The Rococo ushered in a period of individuality, free enterprise, and commercialism. Private workshops were established and artists carved numbers of small statues. If there was, on one hand, a loss of spiritual content, there was, on the other, a gain in charm and vivacity.

*Quitenian
Baroque Sculpture*

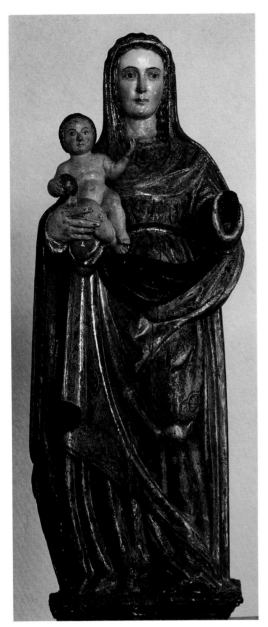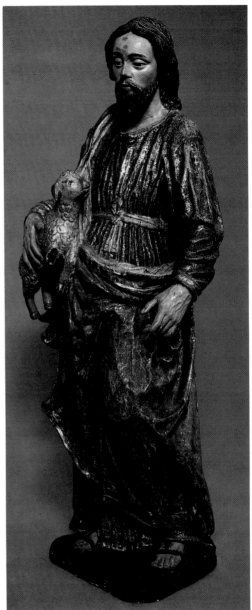

Plate 1 (left). Gaspar del Aguila. *Virgen con el Niño*, c. 1579.
Museum of the Banco Central del Ecuador, Quito. Foto Hirtz.

Plate 2 (right). Francisco de Ocampo. *Jesús Buen Pastor*,
c. 1622. Museum of the Convent of San Francisco, Quito. Foto
Hirtz.

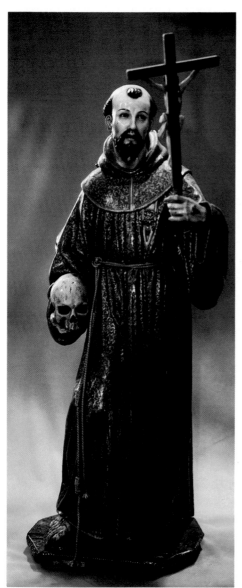
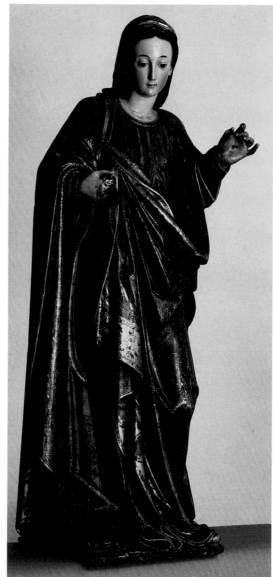

Plate 3 (left). Circle of Martínez Montañés. *San Francisco de Asís*, c. 1622. Church of San Francisco, Quito. Foto Hirtz.

Plate 4 (right). Circle of Martínez Montañés. *Virgen María*, c. 1620–25. Museum of the Banco Central del Ecuador, Quito. Foto Hirtz.

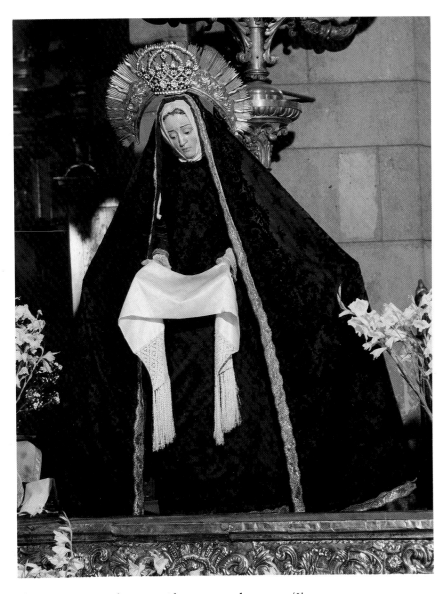

Plate 5. *Virgen Dolorosa*, mid-seventeenth century(?).
Metropolitan Cathedral, Quito. Foto Hirtz.

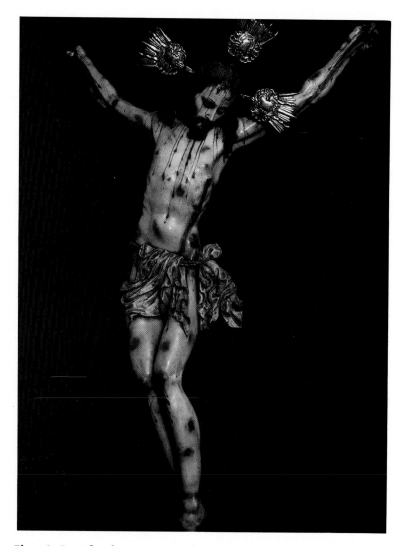

Plate 6. *Crucifijo*, late seventeenth century or early eighteenth century. Fray Pedro Bedón Museum, Convent of Santo Domingo, Quito. Foto Hirtz.

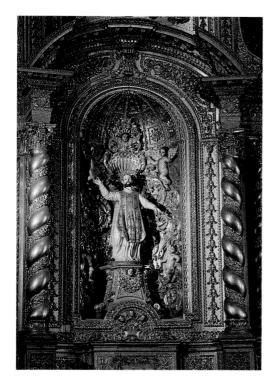

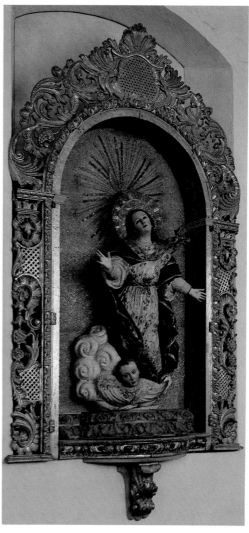

Plate 7 (left). Jorge Vintener (?) *Transept altar,* c. 1743. Church of La Compañía, Quito. Foto Hirtz.

Plate 8 (right). Bernardo Legarda (?). *Asunción de la Virgen,* mid-eighteenth century. Museum of the Convent of San Francisco, Quito. Foto Hirtz.

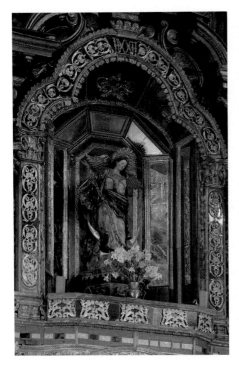
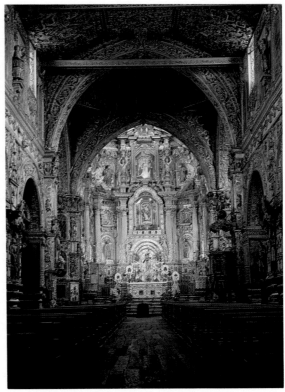

Plate 9 (left). Bernardo Legarda. *Virgen de Quito*, 1734. Church of San Francisco, Quito. Foto Hirtz.

Plate 10 (right). *Main altar*, Church of San Francisco, Quito. Foto Hirtz.

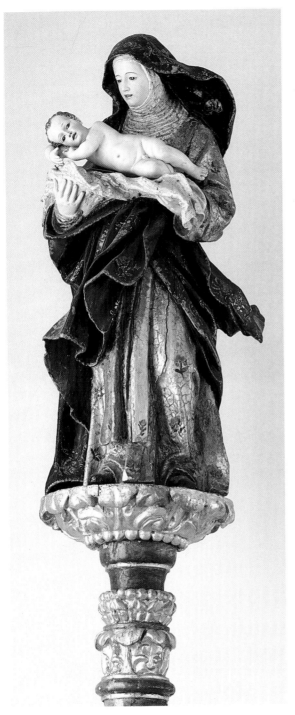

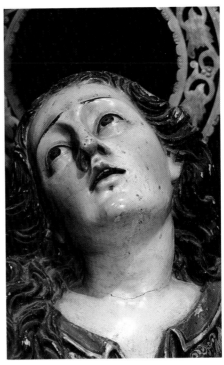

Plate 12. *María Magdalena*, eighteenth century. Church of Cantuña, Quito. Photo courtesy Sra. Ximena Escudero de Terán.

Plate 11. *Santa Rosa de Lima*, last half of the eighteenth century. Museum of Colonial Art, Quito. Foto Hirtz.

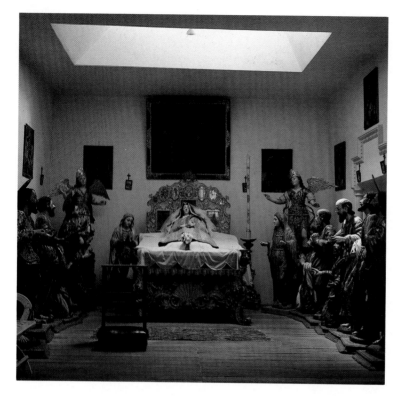

Plate 13. *La Dormición de la Virgen*, c. 1789.
Convent of El Carmen de San José, Quito. Foto
Hirtz.

Plate 14. *Un Apóstol,* detail from La Dormición de
la Virgen. Photo G. Palmer.

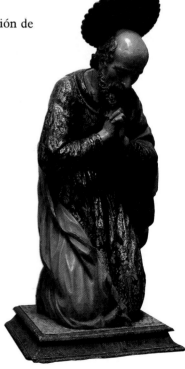

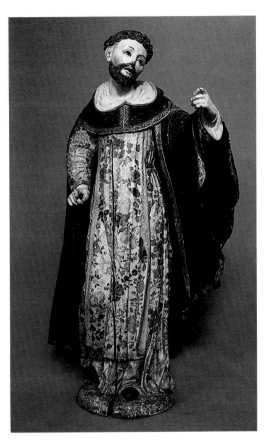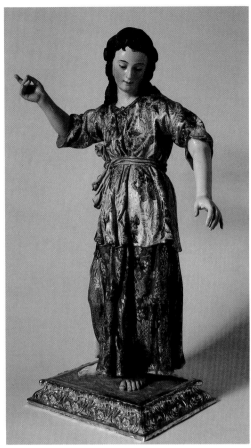

Plate 15 (left). *Santo Domingo*, second half of the eighteenth
century. Museum of the Convent of San Francisco, Quito.
Foto Hirtz.

Plate 16 (right). *Angel de la Guarda*, second half of the
eighteenth century. Museum of the Convent of San Francisco,
Quito. Foto Hirtz.

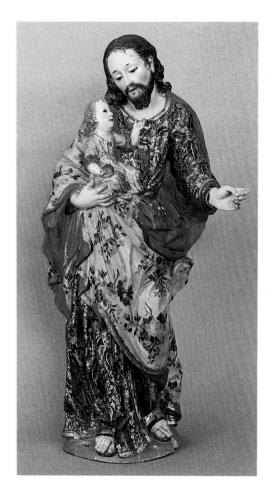

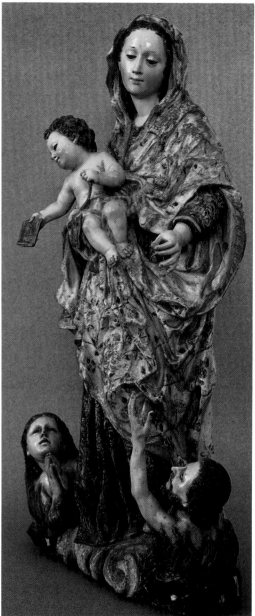

Plate 17 (left). *San José con el Niño*, last quarter of the
eighteenth century. Museum of the Convent of San Francisco,
Quito. Foto Hirtz.

Plate 18 (right). *Virgen del Carmen*, last quarter of the
eighteenth century. Museum of the Convent of San Francisco,
Quito. Foto Hirtz.

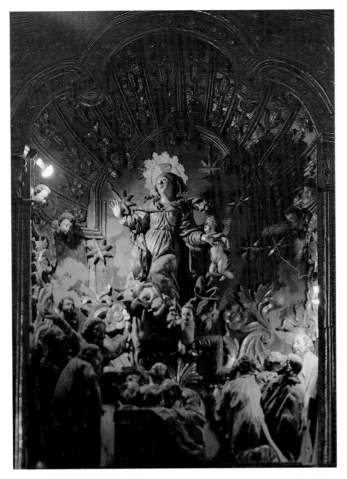

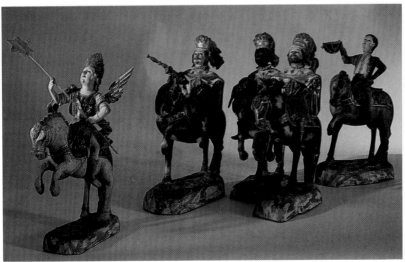

Plate 19 (above). *Asunción de la Virgen*, last quarter of the eighteenth century. Church of San Francisco, Quito. Foto Hirtz.

Plate 20 (below). *Angel de la Estrella, los Tres Reyes, un Embajador*, late eighteenth century. Convent of Santa Clara, Quito. Foto Hirtz.

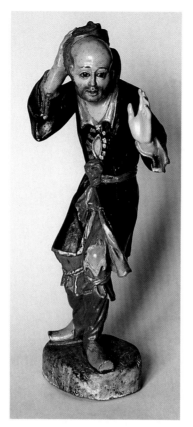
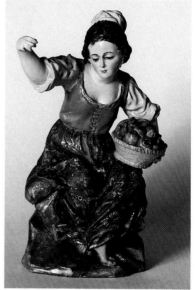

Plate 21 (left). *Man with Wooden Shoes*, late eighteenth century. Convent of La Santíssima Trinidad, Quito. Foto Hirtz.

Plate 22 (right). *Young Woman Seated*, late eighteenth century. Convent of El Carmen de la Santíssima Trinidad, Quito. Foto Hirtz.

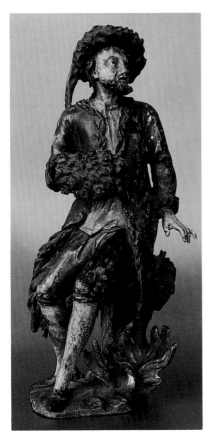

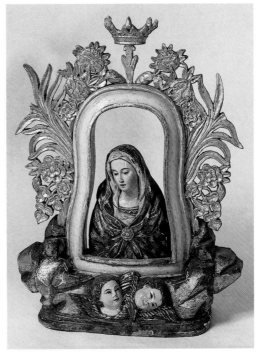

Plate 23 (left). *Allegory of Winter*, late eighteenth century.
Private Collection, Quito. Photo G. Palmer.

Plate 24 (right). *Nuestra Señora de la Cueva Santa*, late
eighteenth century. Milwaukee Public Museum, Milwaukee,
Wisconsin. Photo Milwaukee Public Museum.

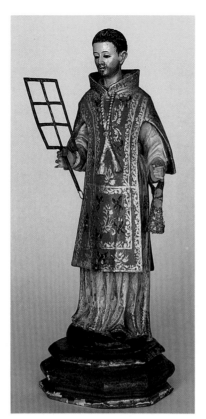
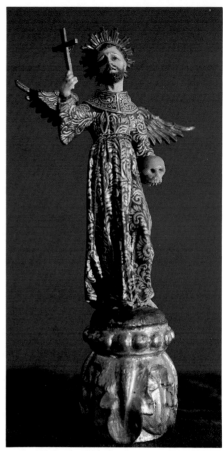

Plate 25 (left). *San Lorenzo*, late eighteenth century. Museum of the Banco Central del Ecuador, Quito. Foto Hirtz.

Plate 26 (right). *San Francisco de Asís*, miniature, late eighteenth century. Museum of Colonial Art, Quito. Photo G. Palmer.

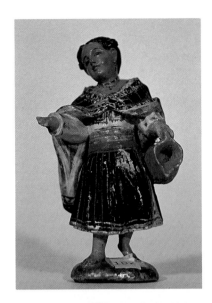

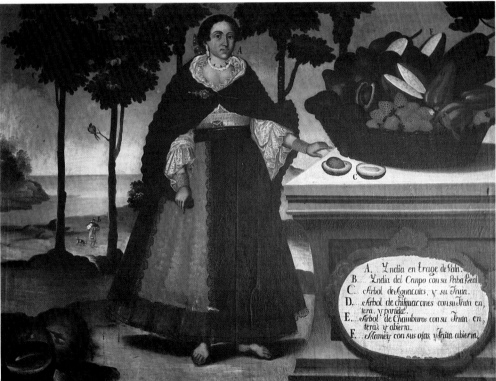

Plate 27 (above). *Indian Woman Carrying an Olla,* c. 1783.
Jijón y Caamaño Museum, Quito. Photo G. Palmer.

Plate 28 (below). Vicente Albán. *India en Traje de Gala,*
painting, 1783. Museo de América, Madrid, Spain. Photo
G. Palmer.

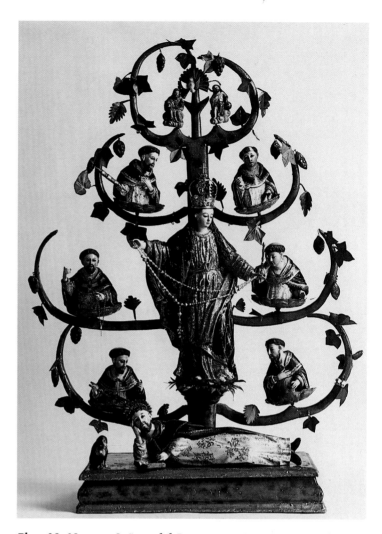

Plate 29. *Nuestra Señora del Rosario*, c. 1783. Convent of Santa Catalina, Quito. Foto Hirtz.

9 *Quitenian Rococo Sculpture*

Transition to the Rococo

The Rococo is perceived by some art historians as the Mannerist phase of the Baroque. Others see it as an independent movement, but as a uniquely European phenomenon. However, as a style, and even more as an attitude, the Rococo was widespread in Spanish America. It was a period of secularization and materialism, which profoundly affected both art and society.

The Rococo period in Quitenian colonial sculpture was at its height in the last quarter of the eighteenth century and in the early years of the nineteenth. The year 1803 serves as a convenient date since it can be said that at this moment the Neoclassical was officially introduced. Many small images were carved during this period though individually they are almost impossible to date, and the names of most of the sculptors remain unknown. However, many of the carvings do reveal distinctive stylistic traits which suggest the presence of an increasing number of private *talleres*. The Rococo corresponds to the period in which both free trade and free enterprise were of paramount importance. In Spain, economists sought remedies to reverse the economic decline from which the country had suffered at the end of the seventeenth century. The resultant reforms, implemented in the last half of the eighteenth century, did much to improve the economy not only in Spain but in her colonies as well. The economic reforms begun under the reign of Ferdinand VI (1746–59) made possible

the further achievements under the reign of Charles II (1759–88). In 1774 for the first time free trade was allowed between the colonies. In 1765 an edict was issued breaking the monopoly of Cádiz and Sevilla as the only ports allowed to trade with the Americas and opened this traffic to many other ports as well. These were golden days for the Kingdom of Quito, and for other South American colonies. Quitenian colonial sculptors found a ready market for their wares.

The famous Quitenian sculptor Manuel Chilí, called Caspicara, was also at work in this epoch, and many carvings are attributed to him. However, in the absence of any serious comparative studies or rigorous analysis of his stylistic traits, it is difficult to make such attributions with any degree of accuracy. Since he worked during the Rococo he serves as a representative of this whole stylistic period.

With the shift from church patronage to the vicissitudes of the open marketplace, sculptors turned from their former preoccupation with religious subjects to representations of the secular world, to genre themes drawn from everyday life. While the Quitenian sculptor continued to look to earlier Spanish prototypes and to engravings for inspiration, nativity scene carvings and imported European porcelain figurines provided him with new models which opened a door onto this secular world.

In contrast to earlier statues, Rococo images were neither linked to a niche in an altar, nor even bound to the setting of the church. Indeed altars themselves were free-standing as the vogue in portable altars gained favor. The niche too detached itself, and in the late Rococo when miniature carvings were so prevalent they were often placed in carved and gilded wooden niches, or *urnas,* many decorated with mirrors. One of the predominant compositional forms was a sinuous double curve, a conscious assymmetry, another was the ascending spiral. This last was particularly noticeable in small carvings of dancers which seemed to spin, so animated was their pose. During the Spanish period and during the Quitenian Baroque the emphasis had been on the single free-standing figure. In the Quitenian Rococo, designs composed of a number of integrated elements were common. Once detached from the architectural niche, Rococo carvings steadily decreased in size. Early Rococo images were three or four feet tall; later the standard size was around twelve or fourteen inches, while at the very end of the Rococo period some miniatures measured less than one inch in height. Unlike larger images of past periods, these were not solely revered as religious icons. Many small wooden figurines were carved which were principally dec-

orative and intended for use in a home. Although there was a loss in solemnity and significance in the art of sculpture, there was a gain in congeniality. Quitenian Rococo carvings, buoyant and brilliantly colored, carried with them a sense of accelerated motion, of joy and informality.

Notwithstanding the change of emphasis in the Rococo, one form of statuary was still prevalent, a form which by its very ephemeral nature has left no tangible record. Religious processions had long been a part of both Spanish and Spanish colonial cultures. During the Rococo era, religious processions became more frequent and more sumptuous, and were held not only on such traditional occasions as Corpus Cristi but throughout the year as well. Documentary accounts attest to the elaborate preparations and considerable expense these celebrations entailed, to the quantities of embroidered cloth, ornate silver ornaments, paintings, and sculptures which were commissioned for such events. Like the fireworks that usually accompanied religious processions, the art at their service had a passing brilliance and was consumed in one dramatic display. The Rococo style manifested itself in Quito in works which seem most meaningful when presented in the following categories.

Transitional Carvings

Several Quitenian carvings can serve to illustrate the subtle transition from the Baroque to the Rococo style. Two carvings of Saint Dominic can provide a comparison. In the first image, the pose—the saint is gazing intently at the crucifix held aloft—harks back to the 1622 Montañés carving of Saint Francis; the drapery is also indebted to earlier Spanish models and the expression of pathos is pure Baroque. In another Saint Dominic a subtle shift can be discerned. The pose is more sinuous, the turn of the head sharper, the curls carved more crisply, the volume is more compact; the genial curve of the arm, the general concept of grace take preeminence over religious feeling. The *encarnación* is clear and light. The dominican habit is splashed with color, and the edges are highlighted in gold.

This same concern for ease and grace is evident in an image called the Guardian Angel. It may once have been accompanied by a smaller figure toward which its slightly pensive gaze is directed. The hair falls in loose waves. The almond shape of the eyes with the lashes painted only on the lower lid is a detail found in a number of late eighteenth-century sculptures and may denote the work of a single important workshop.

Figure 37

Plate 15

Plate 16

Quitenian Rococo Sculpture

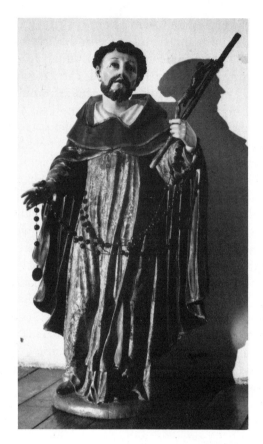

37. *Santo Domingo,* second half of the eighteenth century. Museum of Colonial Art, Quito. Photo G. Palmer.

It was the custom in seventeenth-century Spain for a sculptor, once a statue had been carved and primed, to turn it over to the member of another guild who would then paint it. In Spain, famous sculptors such as Montañés collaborated with eminent painters. In the records of the city of Quito, in 1741, the designation *pintores y encarnadores* appears for the first time, indicating that a guild of painters had been officially established. The following year a guild of *escultores y doradores,* sculptors and gilders, appears in the same records. Since *encarnar* refers specifically to the type of finish a painter would apply to a sculpture, it may be assumed that a system similar to the Spanish one had now been established in Quito. It may be inferred that these two guilds worked closely with each other and that the services of both were necessary to complete a carved statue. The likelihood is that well-known carvers allied them-

selves with a painter of renown to ensure the quality of the finished product.

The carefully observed natural detail with which the flowers in the polychromy of this period are painted may reflect the influence of the work of certain Quitenian artists who collaborated with the Spaniard Celestino Mutis on his monumental botanical work, *La Flora de Bogotá*. Mutis had come from Spain to New Granada (present-day Colombia) to found a scientific institute dedicated to the study of South American flora, which in 1783 was officially designated as the Botanical Institute of Bogotá and placed under royal patronage. In 1786 Mutis was joined by a number of painters chosen from some of Quito's best-known workshops. They collaborated with him over a period of years and their drawings form part of an invaluable collection now in Madrid's Jardín Botánico. The precision and training required for such work no doubt helped influence Quitenian art as a whole. Indeed, in both painting and sculpture, attention to detail and a growing interest in realism were apparent.

Brightly colored polychromy was not always the rule. In one statue of Saint Anthony of Padua the background is no longer a light color but a dark one and the pattern is only elaborated in gold. In this image the curves and counter curves of the Rococo predominate; the edges of the drapery eddy and swirl, a motif which is reiterated in the polychromy whose designs almost seem to spin like pinwheels. But while statues of a larger size continued to be carved, the smaller-than-life-size carvings became one of the hallmarks of the Rococo.

Figure 38

Small Carvings

During the Rococo engravings continued to provide a source of designs for the sculptor. Such is the case of Our Lady of Light, Patroness of the Jesuit Order. In a brilliantly colored carving of this subject, the Christ Child hands a basket full of bright red hearts of the redeemed to an angel who kneels on a rather insecure cloud pedestal, while the Virgin rescues an individual from the jaws of a green dragon.

Figure 39

Not only were engravings and woodcuts of this subject widely circulated, but subjects such as the Immaculate Conception, Our Lady of Mount Carmel, Our Lady of the Rosary, and portrayals of various saints were also common. In some cases the engraving used was a rare one. Such is the case of an engraving executed in 1771 by Francisco Muntaner for the bishop of Mallorca and distributed by the Royal Academy of San Fernando in Madrid, which served

Figure 40

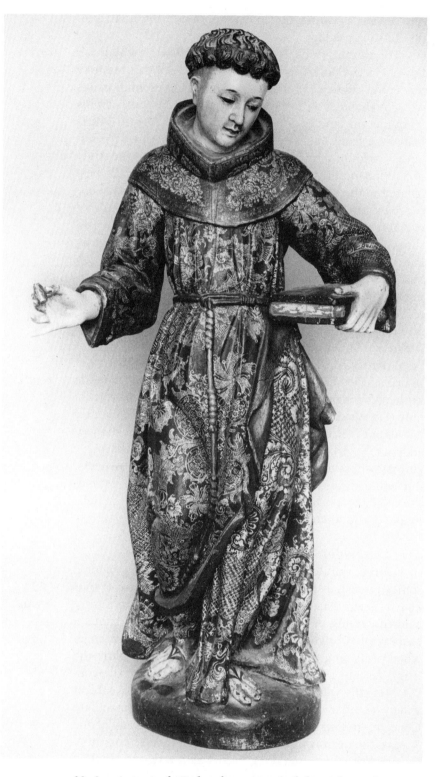

38. *San Antonio de Padua,* last quarter of the eighteenth century. Private collection, Quito. Foto Hirtz.

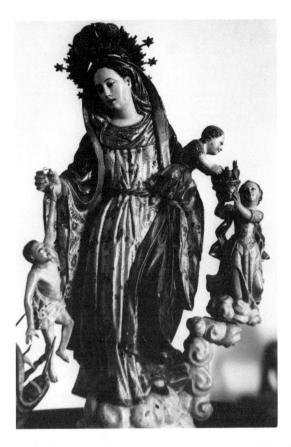

39. *Virgen de la Luz*, eighteenth century. Museum of the Banco Central del Ecuador, Quito.

as model for a small Quitenian carving of the same subject. The sculpture successfully translates the central image of the engraving into a three-dimensional image completely encircled by the flowing lines of the drapery.

Although engravings were the sculptors' primary origin of design, seventeenth-century statues continued on occasion to serve as models for Rococo sculpture. When earlier statues were copied, they were subtly altered to conform to the more contemporary style, and even after it was no longer the custom to copy them in their entirety, the Quitenian sculptor returned to the originals for a single detail. One small eighteenth-century statue of Saint Joseph and the Christ Child is clearly indebted to a seventeenth-century carving of the same subject. The pose of the earlier life-size figure and that of the much smaller and later carving are identical as are certain unique features like the stray lock of hair on Saint Joseph's forehead, the gesture of his

Figure 41

Plate 17

*Quitenian
Rococo Sculpture*

117

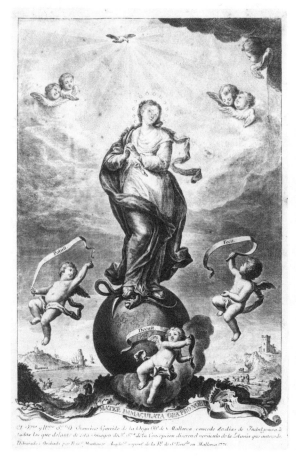
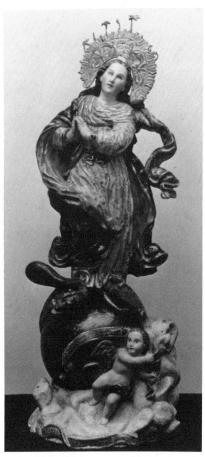

40 (left). Francisco Muntaner. *Mater Immaculata.* Engraving, 1771. Museo del Arte Moderno, Barcelona, Spain.

41 (right). *Inmaculada Concepción,* eighteenth century. Private Collection, Quito. Foto Wuth.

right hand, and the manner in which the neck of the robe forms a pleat. However, the axis of the Rococo carving forms a sinuous S curve, and the polychromy is delightfully gay. The decoration of flowers and abstract patterns outlined in gold almost completely obscures the dark background of the robe. The yellow cloak is scattered with roses and lined with a brilliant red whose spreading warmth seems to echo the close emotional bond between the two figures.

Plate 18 A companion statue, *Nuestra Señora del Carmen,* belongs to the same period and may be the work of the same sculptor. Based on an engraving of a type very common in this period, the various elements of the composition are joined through a series of linked gestures. The Virgin Mary and the Christ Child lean toward the other figures who are

surrounded by the flames of Purgatory from which they reach forth, pleading for intercession. The white and gold of the draperies and the cool porcelain-like *encarnación* give the carving a remote elegance.

The same clear *encarnación* can be seen on a statue of the Resurrected Christ, only twelve inches high, which was *Figure 42* also based on an engraving. The nude was not frequently portrayed in Spanish sculpture, and only in representations of Christ was the nude body, always partially draped, actually exalted. Quitenian sculpture followed this custom. As previously noted, some fine carvings of the Crucified Christ did come to Quito from Spain in the seventeenth century. Others were later carved by the colonial artists of the Baroque. In the Rococo there are a number of fine small carvings of the Crucified Christ, pictured both on the cross and lying prone, after His descent from the cross. This carving, however, exalts the theme not of death but of the Resurrection. Christ stands lightly poised, gazing upward, two fingers raised in benediction. The anatomical proportions are precise and correct. The folds of the loincloth act as a foil for the clear, faintly luminous *encarnación*, and the delicately modulated surface evokes a sense of tactile immediacy. Here the work of the painter has enhanced the work of the sculptor.

The ethereal is invoked in a statue of the Archangel Gabriel, which must once have been part of a group which *Figure 43* included Raphael, Miguel, and Uriel. Several such groups are still extant and may have been the work of a single workshop. No known prototype for such figures exists in Spanish sculpture, and it may be that they were inspired by porcelain figurines. The Archangel Michael was often *Figure 44* portrayed in Quito since he had been elected Patron Saint of the city on January 12, 1656, by vote of the town council *para siempre jamás*, "forever and ever," and a yearly procession was held in his honor. Indeed the population of carved wooden angels in eighteenth century Ecuador was astounding and their worship ubiquitous. Coletti reports with some disdain that the Indians dancing at important festivals were often dressed in a skirt and a woman's hat lavishly decorated, their faces covered with a mask, rattles and bells strapped to their legs. Thus decked out they wandered the streets and, he adds, had the audacity to call themselves angels! Carvings of angels covered the doors of "portable" altars. The age of the great church retablos had passed and now the wood carver turned to the execution of smaller altars with hinged front doors, of elaborate frames, of enormous gilt thrones for the Virgin.

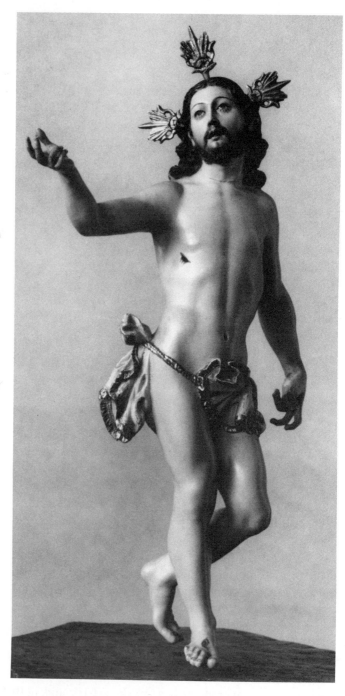

42. *Cristo Resuscitado,* late eighteenth century. Museum of Colonial Art, Quito. Foto Hirtz.

Chapter Nine

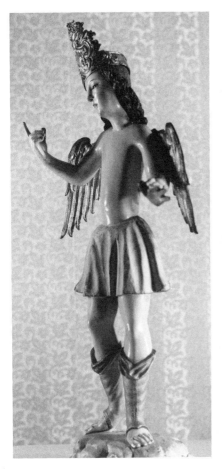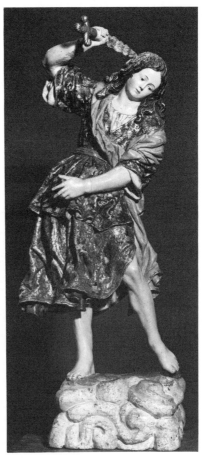

43 (left). *Arcángel Gabriel*, last quarter of the eighteenth century. Private Collection. Photo G. Palmer.

44 (right). *San Miguel*, late eighteenth century. Municipal Museum Alberto Mena, Quito. Foto Mas.

One unusual group depicting the Assumption of the Virgin is located in a high niche in one of the elaborate mirrored transept altars in the Church of San Francisco. It belongs in part to the Baroque with its illusionistic use of space and the emphasis on the theater, as if the viewer were looking in on an event which had just taken place. The Apostles stand around the open sarcophagus above which the Virgin rises to heaven on a cloud of angels. The design was no doubt based on an engraving similar to the one executed by the Flemish artist Abraham Bloemart. The division of the Apostles into three groups is the same in both, as is the figure in the left foreground with his back to the viewer. The Apostles register their wonderment and awe through a series of animated gestures. The style of this group is in part Baroque, with its emphasis also on illusion

Plate 19

Figure 45

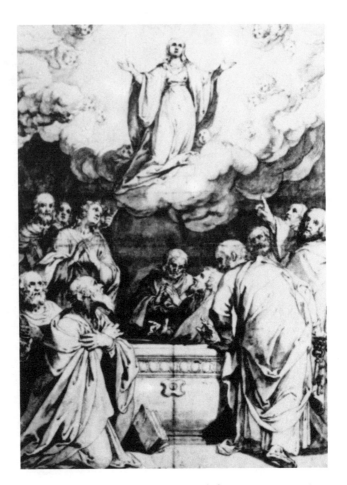

45. Abraham Bloemart. *Assumption of the Virgin*, engraving, c. 1620. Utrecht, Netherlands.

and on a theatrical presentation. But the size of the figures, the animation of the polychromy proclaim the influence of the Rococo.

Figure 46

One theme common to seventeenth-century Spanish sculpture was the portrayal of the Child Jesus. In Quito this was a Rococo theme. In one example, the soft rounded curves are more reminiscent of Italian Renaissance sculpture than of any Spanish prototype. Among the subjects of Rococo sculpture in Quito were small carvings representing the Nativity of Christ. And in these, of course, the Christ Child was the central figure.

Nativity Scenes

Although the representation of the Nativity was one of the oldest artistic themes in Christianity, Saint Francis of Assisi is often credited with originating the religious cult

46. *Niño Jesús*, late eighteenth century. Private Collection, Quito. Foto Hirtz.

in honor of the event. Legend has it that in 1223 he orga-nized a drama based on the events of the Nativity. In time, the central figures of this dramatic portrayal were replaced by carved wooden statues carried in procession. Later, it also became the custom for smaller carved statues to be placed on miniature stages representing the manger scene. At first reserved for churches and convents, later these also were placed in private homes as the tradition grew increas-ingly popular.

Naples was one of the great artistic centers for the carving of nativity scenes. The earliest examples of the Neapolitan *presepios* were limited to the representation of Mary, Joseph, and the Christ Child, accompanied by the Magi and shepherds in adoration. Later these central fig-ures were joined by many others forming a long procession toward Bethlehem. While in Naples, Charles of Bourbon

championed this popular devotional art. As King Charles III of Spain he commissioned artists to fashion hundreds of figures for a nativity scene which was installed in a special room of his palace in Madrid. He invited the citizenry to visit, thus contributing greatly to the popularity of this fashion. Disseminated throughout the Catholic world, nativity carvings also enjoyed a great vogue in the Spanish colonies where they were known as *Belenes* (Bethlehems) or *nacimientos*.

In colonial Quito the festivities of the Christmas season were colorful joyous occasions in which the nativity scene played an important part. All of the convents and many of the aristocratic families owned Belenes, and in time, so did the lower classes. Religious tradition dictated that the Belén be prepared on the fifteenth of December. This was often the occasion for a procession. Appropriately costumed, angels, shepherds, the Three Kings, and "natives" marched at the head of the procession while young boys ran gaily alongside rattling drums and blowing flutes. These celebrations culminated on Christmas Eve. Everyone wore his finest clothes, all the candles were lit, the most pious prayers murmured, and the sweetest songs sung in honor of one of the greatest events in Christendom.

In colonial Quito there were large collections of nativity scene figures. Today the most representative collections belong to the various Quitenian convents, where separate rooms have been reserved for their display. The Santa Clara collection contains the greatest number of biblical scenes—the Annunciation, the Presentation at the Temple, and others. In the collections of other convents a greater number of secular figures, many inspired by European porcelains, are displayed.

Figures 47, 48

In most nativity scenes, the figures of Mary, Joseph, and the Christ Child were traditionally larger than the figures surrounding them. One pair of Mary and Joseph, among the finest of its kind, is noteworthy for the warmth and humanity of its characterizations and for the beauty of its polychromy. Another group shows Mary, Joseph, and the Christ Child.

Figure 49

From the seventeenth century, Christmas celebrations in Spain had included the presentation of liturgical dramas, a tradition transmitted to the colonies by the religious orders. These dramas provided the Quitenian sculptor with a new source of inspiration for his work. One nineteenth-century account of a festivity held in the town of Popayán describes one of these *pastorelas*. The entire city participated in the celebration of the arduous journey taken by

Chapter Nine

47 (left). *Virgen María*, late eighteenth century. Private Collection, Quito. Foto Hirtz.

48 (right). *San José*, late eighteenth century. Private Collection, Quito. Foto Hirtz.

the Magi toward Bethlehem. The procession was led by the Angel of the Guiding Star carrying a star-tipped wand and riding a white horse whose mane was braided with colorful ribbons. Following him were various "ambassadors" in the formal attire of diplomats, who were to petition King Herod for permission to enter and pass through his lands. Behind them, dressed as oriental potentates and mounted on magnificent horses, came Caspar, Melchior, and Balthasar; these were actually represented by members of the white, Indian, and black races. Three fine mules laden with gold, frankincense, and myrrh were followed by pages dressed in livery and carrying sumptuous gifts; then came shepherds carrying humbler gifts and leading sheep crowned with garlands of flowers.

Although the Popayán account dates from the nineteenth century, it has its roots in an earlier eighteenth-

*Quitenian
Rococo Sculpture*

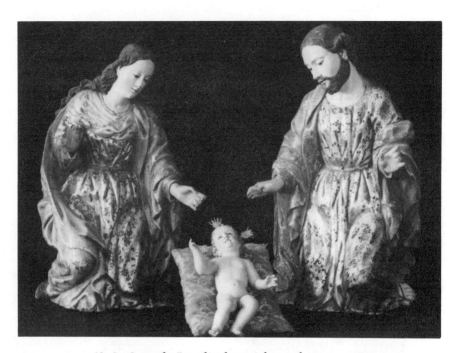

49. *La Sagrada Familia,* late eighteenth century. Private Collection, Quito. Foto Hirtz.

Plate 20 century tradition of popular Christmas drama. Five carved wooden figures in a Quitenian Belén appear to have ridden straight out of just such a procession and onto the miniature stage which they now occupy. Led by the Angel de la Estrella on a white horse, followed by the Three Kings and the "ambassador" in eighteenth-century breeches and tricorn hat, these carved images faithfully recreate the actors of the living drama. In European nativity scenes, the Magi were traditionally accompanied by camels laden with gifts. In Quito, these animals were often replaced with a local beast of burden, the graceful but haughty llama. Symbols of truculence and independence they are reputed to spit on the man who tries to place too much weight on their backs!

The Flight into Egypt was a common feature of many Figure 50 Quitenian nativity scenes. In one brilliantly polychromed example, Saint Joseph leads the donkey whose slow, careful pace seems to reflect a special concern for those he carries on his back. Other biblical scenes included in Belenes were the Visitation, the Massacre of the Innocents, the Annunciation, and the Garden of Eden with its central figures Adam and Eve. In one characterization of Adam he hides his head in shame while Eve (not illustrated) reclines seductively at his feet.

Figure 51

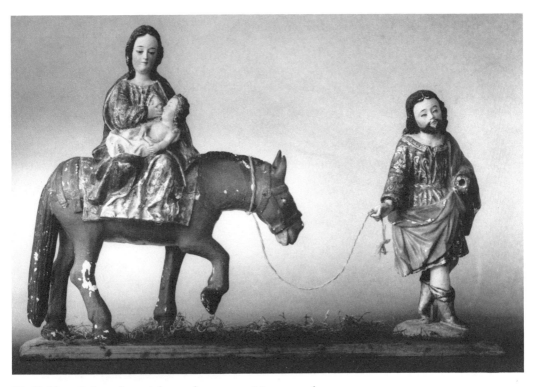

50. *Huída a Egipto*, late eighteenth century. Museum of Colonial Art, Quito. Foto Hirtz.

In addition to religious characters, the Quitenian Belén gradually began to include secular themes. These included affectionate, sometimes humorous, portrayals of everyday life—an Indian barber bending over the half-shaved face of his patron, two boys sitting primly on a bench, dancers performing a minuet, and so forth. The prototypes for some of these figures come from European wood carvings such as the *Man with Wooden Shoes*, probably based on a Span- *Plate 21* ish original. But the Europeans or upper classes were not the only ones shown; rather the whole population in all of its ethnic diversity came to be portrayed—the mestizo woman going to market with a plate of butter, the *sereno*, or nightwatchman on his rounds, Negro dancers, and Indian musicians playing their typical instruments. Indeed the dance appears to be one of the principal activities of the secular figures in these nativity groups. They spin and twirl like tops, bow and turn with petticoats flying. Many of the dances were of European origin, the minuet, the *pasapie*, and the *amable*, although dances of more popular character were the ones most common in the Americas. Some of these were noticeably influenced by the music which the

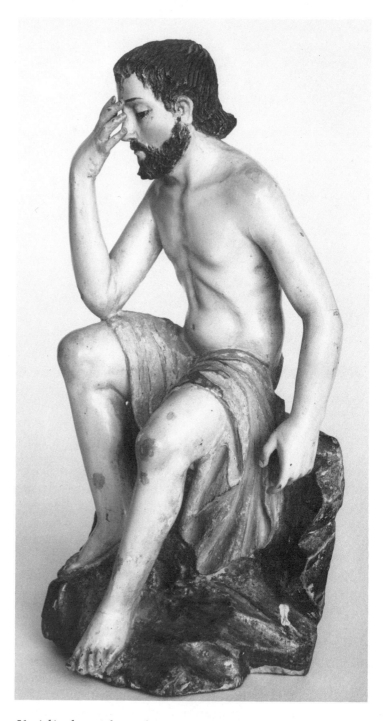

51. *Adán*, late eighteenth century. Museum of the Banco Central del Ecuador, Quito. Foto Hirtz.

Chapter Nine

Negro slaves brought with them, particularly the licentious fandango, which at one point was forbidden by law. One miniature carving shows such a Negro dancer entirely caught up in its rhythm. In earlier examples of Baroque statuary, draperies eddying around a carved image imparted a sense of motion; in the Rococo the tempo quickens and figures appear to spin in a vortex of energy (see page 145).

The general gaiety was in part a reflection of the change in the Spanish attitude for, under the rule of Charles III theaters and playhouses, *Casas de Comedias*, were opened and masked dancers and actors were allowed to stroll the streets. In the reign of Philip IV festivities at carnival time came into vogue. In Quitenian nativity scenes figures wearing eye masks and dressed in satyric fashion attest to the presence of similar festivities in the colony.

While some nativity carvings continued to be modeled after engravings or imported European prototypes, an increasing number took their inspiration from real life and faithfully recorded details of Quitenian colonial life. This type of genre figure found its inspiration in the European porcelain figurine. Under its influence Quitenian carvers turned increasingly to the execution of small carvings. In Quito, as in Europe, porcelain figurines introduced the secular world into art. A number of such small figures, inspired by porcelain prototypes, were eventually included in Quitenian nativity scenes.

Porcelains

The art of porcelain had its origins—perhaps as early as the ninth century—in the Orient. From this far and fabled land Marco Polo brought the first porcelain to Europe in 1295. In subsequent decades oriental porcelain—vases, plates, figurines—was exported to the West in great quantities and was highly prized. Nonporous, clear, and white, oriental porcelain could be glazed with colors and molded into objects of extreme delicacy. Repeated attempts were made to reproduce it in Europe. All efforts were unsuccessful until 1708 when the precise formulas of kaolin and feldspar were discovered. In 1710, the Meissen factory was established near Dresden. At first, its works were derivative and based on oriental models, though gradually more original subjects and forms were produced. The porcelain figurine developed into one of the most significant and characteristic forms of eighteenth-century art.

Soon after Meissen, other factories were founded: Sèvres in France, Bow and several others in England, and Capodimonte in Italy. Capodimonte had been established by

*Quitenian
Rococo Sculpture*

129

Charles of Bourbon who later inherited the throne of Spain. When he left Naples to assume the Spanish crown as King Charles III, he took with him many of the Capodimonte workers and much of their equipment. With them he established the Buen Retiro factory in Madrid in 1760. Most of its production was reserved for royal use until 1788. By contrast, European factories such as Meissen, Bow, and others were commercial enterprises. Their wares were sold in Europe and exported to the American colonies.

By 1773 the popularity of the porcelain figurine was firmly established throughout Europe; the decade of the 1780s is considered to be the period of its greatest influence and diffusion. Both "hard paste" or true porcelain, based on the original Meissen formula, and "soft paste," in which ground glass was substituted as one of the principal ingredients, were the materials employed. Figurines were first shaped by a master craftsman, and a master mold was made from which copies were then cast in series. The individual pieces were painted by hand and then fired to fix the colored glaze. Porcelain figurines were presented in three principal styles—Baroque, Rococo, and Neoclassical. The Baroque figures were full of movement and grandeur, although after the mid-eighteenth century there was a turn toward the Rococo and the representation of a more charming, intimate world. The whole range of porcelain subjects—cavaliers and their ladies, singers and musicians, lovers, peasants and fishermen, peddlers, shepherds and shepherdesses, Moors and Chinamen, figures from the Italian comedy, and dwarfs inspired by Callot engravings—were often portrayed as if they belonged to court circles, to a pleasant, if artificial, arcadian world. Since many figures were intended as table decorations, they were often made in sets and included such allegorical representations as the four continents or the four seasons. The Neoclassical style in porcelain appeared toward the end of the century and turned to themes of classical mythology and to relatively unadorned monochromatic figurines.

Although little is known of the New World trade in European porcelains, its rise coincided with a period in which most goods destined for South America were supplied by countries other than Spain. Some of these fragile European porcelains reached Quito. Although only a few have survived, their influence is everywhere apparent, and it is clear that many small carved wooden figures are indebted, in varying degrees, to these porcelain prototypes.

A pair of these porcelains, entitled The Gardners and manufactured by the English Bow factory in 1760, must

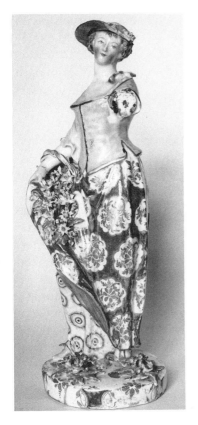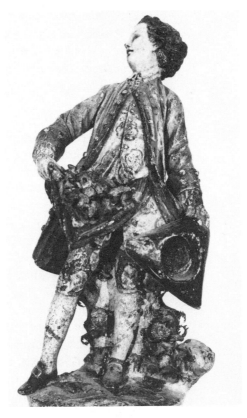

52 (left). *A Lady Gardner.* Bow Porcelain figurine, c. 1760. Convent of La Santíssima Trinidad, Quito. Foto Hirtz.

53 (right). *A Gentleman Gardner,* last quarter of the eighteenth century. Jijón y Caamaño Museum, Quito. Photo G. Palmer.

have been exported to Quito. Only one of the original porcelains has survived—the figure of the woman. Her partner is a Quitenian copy carved in wood. Faithful to the original in every detail, the sculptor has even retained the brace which was necessary in the manufacture of porcelains to keep the figurines from shrinking and breaking. In most cases it is not possible to draw such an exact parallel between European prototypes and Quitenian copies.

Quito briefly had her own porcelain factory. Established in 1771, by 1777 it was producing porcelain of the soft-paste variety—baskets of flowers, shepherds, allegorical representations of four continents, religious subjects, and popular types—exact duplications of contemporary European themes. Few European or Quitenian porcelains have survived. However, many small Rococo carvings are clearly related to porcelain prototypes. These include shepherdesses, stylishly dressed members of the aristocracy, dan-

Figure 52
Figure 53

*Quitenian
Rococo Sculpture*

cers and musicians, itinerant merchants, and the like. In Europe it was common practice for ivory carvers to be closely allied to porcelain factories. In this same Rococo period, ivory carvings were also exported to the colony, from both Europe and the Orient.

Ivory and the Orient

It should not be assumed that the only trade with the Americas was European. The commerce which existed between the Philippines and the Americas rivaled it in importance and often surpassed it in luxury. From 1565 to 1821, galleons made yearly round trips from Manila, the distributing center for various parts of the Far East, to the west coast of the Americas. However, most of the merchandise to reach Manila came from China; hence, the galleons came to be known as the *Nãos de China*.

At first, most of this cargo was destined for Europe. Spanish authorities, anxious to maintain their own monopolies and jealous of any wealth the colonies harbored for their own use, attempted to limit the quantity and extent of this trade. Goods unloaded at Acapulco, Mexico—official port of entry—were intended for direct transshipment to Spain, and distribution to other colonial countries was forbidden. However, these orders were routinely disobeyed. By the early eighteenth century the traffic between Manila and South America was frequent and customary.

Ships' manifests at this time included silks, brocades, damasks, and tapestries; gold, silver, and colored silk thread for embroideries; musk and ivory, pearls and rubies, sapphires and crystals, spices and preserves; chestnuts, pears, green oranges, ducks, horses, and mules; lacquer ware and, of course, porcelain. The type of porcelain known as blanc-de-chine was exported in great quantities from Fukien Province in China and must one time have been present in Quito. However, the occasional oriental porcelain found in Ecuador today is a curiosity. Any direct influence of such porcelains on Quitenian Rococo sculpture was negligible, although subtle oriental influence can be perceived.

Oriental ivory carvings were also received in some quantity in Quito; often these took the form of face and hands carved of ivory which were incorporated into statues *Figure 54* such as *La Virgen de Quito*. The oriental cast of the face is apparent. More elusive is the oriental influence in a small *Figure 55* carving of Saint Mary of Egypt, a favorite subject of poetry and popular romances. The design for this image may have come from an illustration in such a text. After her conversion to Christianity, Saint Mary spent forty-seven years in

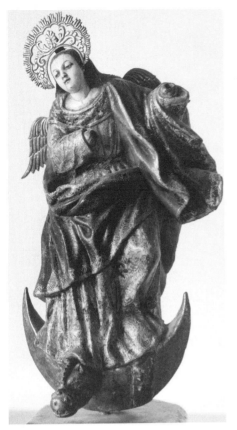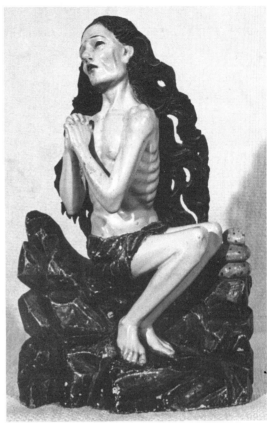

54 (left). *La Virgen de Quito*, eighteenth century. Private
Collection, Quito. Photo G. Palmer.

55 (right). *Santa María Egipciaca*, late eighteenth century. Jijón
y Caamaño Museum, Quito. Photo G. Palmer.

the Egyptian desert repenting her former sinful life. Since
she subsisted on the three loaves of bread with which she
is represented in this Quitenian carving, her body is un-
derstandably gaunt and emaciated. The explicit articula-
tion of the torso and the strained *contrapposto* contribute
to the psychological force of this portrayal. Her long cas-
cading hair is carved in a manner reminiscent of oriental
fretwork.

Ivory also came from Europe. There are numerous small
ivory carvings from the late colonial period, some of which
originated in the Orient, others in Europe. These prototypes
were copied by the colonial sculptor. It will be remembered
that Legarda mentioned an ivory carving in his will. In
some cases the ivory used came from billiard balls. Sawed *Figure 56*
in half, they would then be carved on the face with designs
which always depicted some aspect of the Nativity. Al-

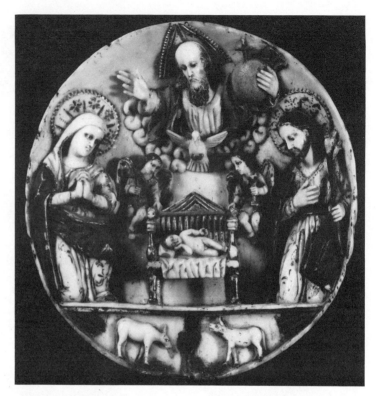

56. *Nativity,* late eighteenth century. Private Collection. Foto Wuth.

though such themes continued to have great importance in Quitenian sculpture, the secular world intruded more and more into a field that had previously been exclusively religious. These two worlds, the sacred and the secular, were both portrayed in carved wooden figurines.

The Carved Wooden Figurine

Figure 57
 A graceful *Mother and Child* clearly reveals the influence of the world of porcelains. The manner in which the woman's sleeves are rolled up is the hallmark of a certain workshop and can be seen in numerous carvings. A *Young* *Plate 22* *Woman Seated* is also modeled after a porcelain figurine, while an elegant wooden carving of a gentleman wearing *Plate 23* a fur hat was probably copied from a Meissen original. As an allegorical representation of winter, he holds a fur muff and warms one hand over an open flame. The gentleman's red breeches and the golden tongues of the flame are finished in the technique known as *corlas.* The undercoat of silver leaf shining through the translucent paint simulates porcelain's vitreous glaze. The same technique was used

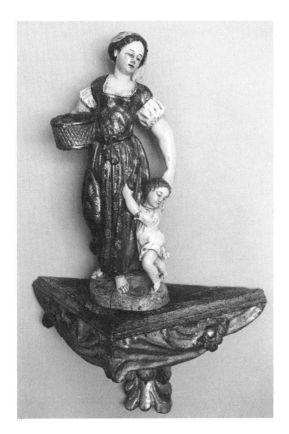

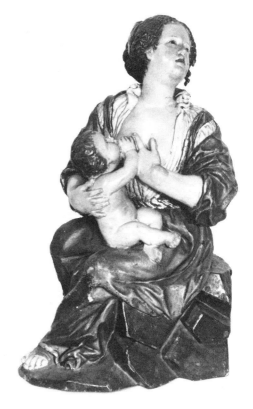

57 (left). *Mother and Child*, late eighteenth century. Museum of the Banco Central del Ecuador, Quito. Foto Wuth.

58 (right). *Mother Nursing Child*, late eighteenth century. Milwaukee Public Museum, Milwaukee, Wisconsin. Photo Milwaukee Public Museum.

in a decorative and equally unusual carving, *Nuestra Señora de La Cueva Santa*, a Spanish cult. Frequently portrayed in paintings on canvas, this particular advocation of the Virgin was above all popularized in paintings on tin retablos which enjoyed a vogue in the nineteenth century. In this example, the delicately sculptured bust of the Virgin receives less emphasis than does the intricately carved and gilded frame. The rocks, rendered in the *corlas* technique, appear iridescent. The use of rocks as a base for small statues may have been derived from the sculpture of Roque López, a disciple of Francisco Salzillo. This feature is evident in a number of Quitenian statues, such as the genre figure *Mother Nursing Her Child.* This carving, and others like it, no longer looked to Europe for prototypes, but sought inspiration in local models, in native Quitenian reality. The local artist relied increasingly on his own imagination.

As figurines became smaller, the details of the carving

Plate 24

Figure 58 *Quitenian Rococo Sculpture*

59. *Angeles*, miniature, late eighteenth century. Museum of Colonial Art, Quito. Photo G. Palmer.

became more precise and the colors more brilliant. One *Plate 25* image of Saint Lawrence serves as an example for a whole class of carvings which were executed in the late Rococo period. Here the saint has been reduced to doll-like proportions, and the grill which he holds in his hand and on which he suffered his extremely painful martyrdom is now nothing but a decorative adjunct. Figures shrank to even smaller dimensions as the late Rococo sculptor turned increasingly to the art of the miniature.

Miniatures

Miniaturization was a hallmark of late Rococo. As early as 1750, the Meissen factory began producing very small porcelain figurines, and during the last half of the eighteenth century, the French also gained fame for their carvings in micro-relief. Quitenian sculptors followed this trend and toward the very end of the century began to carve miniatures, some no more than an inch high.

During this late colonial period, earlier Spanish carvings as well as engravings continued to provide the sculptor *Plate 26* with models. One is a miniature copy of the seventeenth-century Montañés Saint Francis. Purely decorative in intent, the smaller figure conveys none of the spirituality of

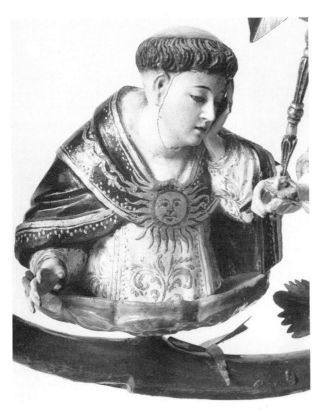

60. *Nuestra Señora del Rosario* (detail). Foto Hirtz.

the life-size original. Miniature angels are dressed in the leather greaves and embossed corselet of a Roman soldier; their fluted skirts epitomize the lilting gaiety of the Quitenian Rococo. Another miniature portraying an Indian girl carrying a clay olla belongs not to heaven but to Quitenian reality. The details of her costume—the full petticoats, the rebozo fastened with a native *tupu*—are also depicted in a painting entitled *India en traje de gala*, executed in 1783 by the Quitenian Vicente Albán. This similarity suggests that Vicente Albán and the sculptor may have worked together and allows the same date, 1783, to be assigned to the sculpture.

The same crisp style and diminutive proportions are in evidence in a remarkable carving which must also be assigned to the same sculptor and given the same date. This intricate carving represents a composite of the themes of Our Lady of the Rosary and of the Tree of Jesse. Our Lady of the Rosary is the Patroness of the Dominican Order, and the Tree of Jesse, in this case, illustrates the genealogical tree of the Dominican Order. The eighteenth-century sculpture was modeled after a painting executed by the Domin-

Figure 59

Plate 27

Plate 28

Quitenian Rococo Sculpture

ican Fr. Pedro Bedón in the seventeenth century. Although frequently copied by the colonial painters of the eighteenth century, the theme is an exceptional one for sculpture. The

Plate 29

Quitenian sculpture, *Our Lady of the Rosary*, though true to the spirit of the painting, takes a few artistic liberties. The prone figure at the base is Saint Dominic; the image of the Virgin is the trunk of the tree. The branches, decorated with clumps of eucharistic grapes curled sharply at the tips, form a markedly pyramidal structure with the

Figure 60

Trinity at its apex. Busts of the most famous saints of the Dominican Order sit poised on the opened petals of a rose. Each holds an attribute such as a scepter, a monstrance, or a martyr's palm to establish his identity—Santo Tomás de Aquino, San Jacinto de Polonia, and others. This extraordinary carving, unique in Spanish colonial sculpture, is perfect in every miniature detail. The carved edges are crisp and sure, the colors bright and clear, the whole rendered with delicacy and spirit.

Decline of Quitenian Colonial Sculpture

On September 21, 1789, according to records of the town council, the city participated in a magnificent celebration to honor the new King of Spain, Charles IV. His portrait was displayed in procession attended by members of the nobility carrying the royal coat of arms encrusted with diamonds. Balls were held for several nights, large amounts of food and drink consumed along with delicately flavored ices made from snows brought down by runner from ice fields of the nearby volcanoes. In the closing ceremony a series of allegorical carts were drawn to the main plaza. On one of them the city of Quito was represented by a lovely maiden dressed in light green and crowned with flowers. Ceremoniously she asked the two noble arts, painting and sculpture, to join her court. These were represented by two matrons dressed in gowns of silver cloth decorated with mother of pearl, and holding a symbolic object. All pledged their loyalty to the new king.[22]

Only a few years later, in 1792, Eugenio Espejo was to write that where once trade flourished, now ships returned half empty to Spain. In these calamitous times, he said, the works of the sculptor Caspicara and the painter Cortés are among the few economic resources that bring money to Quito from the neighboring provinces. However, most of

the artisans, mired in misery, congregate in the market in a vain attempt to sell the wares they have executed in the silence of their dim, ill-equipped workshops.[23]

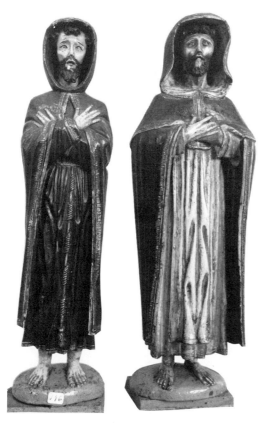

61. *SS. Francisco y Domingo*, early nineteenth century, Jijón y Caamaño Museum, Quito. Photo G. Palmer.

In 1808 the king whose reign the Quitenians had gathered to celebrate so lavishly was forced to abdicate. His successor ruled for only a few months before he too was deprived of his throne and Spain became a modern constitutional government. In 1809, Ecuador won her independence from Spain and established her own form of representational government.

The brilliantly colored statuary for which Quitenian sculptors were renowned also disappeared from the world stage. Under the initiative of Baron Carondelet, president of the Quito Audiencia from 1799 to 1807, the cathedral underwent the last of its many renovations. The architect employed for the work was the Spaniard Antonio García, and it was he who introduced the Neoclassical style to Quito around 1803. In the cathedral there are several plainly painted statues representative of this style. Two smaller carvings, copies of the much earlier Spanish statues of the Saints Francis and Dominic, reveal the same austere spirit.

Figure 61

The column-like figures are reminiscent of the very first carving with which this study began, the *Virgin and Child* by Gaspar del Aguila. This change in style coincides with the end of the colonial period and heralds yet another transformation in the collective psyche.

Conclusion

The Seasons of Art:
A New Look at Art History

In this survey, the historical development of the sculpture of Quito during the Spanish colonial period has been described primarily by its relationship to European art. Such terms as *Gothic, Renaissance classicism, Realism, Baroque,* and *Rococo* have been used to delineate certain stylistic characteristics. The relationship of Quitenian colonial sculpture to Spanish sculpture as well as to the broader currents of European art in the sixteenth, seventeenth and eighteenth centuries has been analyzed. This explains the chronological transmission of styles from Europe to the New World. However, this method is woefully inadequate to account for the emergence of Spanish colonial art and to explain its vitality and originality. There is an urgent need for a new perspective.

The mythologist Mircea Eliade may have had a similar idea in mind when he wrote that "the supreme merit of any historian of religions is precisely to endeavour to discover in a 'fact' duly conditioned by the historical moment and the cultural style of an age, the existential situation that caused it."[24] Such a challenging insight is equally valid for the historian of art who searches beyond the life and style of the individual artist, past the limitations of a particular historical period, and who seeks to uncover the patterns that underlie events in time. In the preceding chapters certain selected statues have revealed an undercurrent present in the historic development of Quitenian colonial sculpture. My hypothesis is that they reveal the nature of

Eliade's "existential cause." In order to justify this hypothesis, a link between the realms of psychology and art must be established.

The art historian Germain Bazin provided a valuable clue when he perceived in certain characteristics of sculpture the expression of a psychological principle. "In painting, the background and the figures depicted on it are held in common bondage," he has written, "[Whereas] sculpture has a looser relationship to its ground." Citing a statue of Saint George by the Italian sculptor Donatello, he says, "It marks the point at which Donatello's individuality begins to affirm itself. . . . Freeing the statue from the architectural frame to which it had been subordinated in the Middle Ages, he made it a self-sufficient organism moving freely in three dimensional space."[25] Thus, in speaking of sculpture, Bazin relates the degree of flatness or roundness, the degree of detachment from the background to the principles of self-reliance and emancipation.

Bazin used a single sculpture to make his statement. However, the same observation may be expanded to include the works of an entire community. In the context of this present study, it illustrates the development of Quitenian society during the colonial period. The progressive articulation of spatial freedom in Quitenian colonial sculpture expresses the gradual emancipation of the Quitenian people which comes to fruition in the course of the eighteenth century. In Quitenian culture, the development toward self-reliance is expressed not only by the individual sculptor, but by the entire community of Quitenian artists, all of whom contributed to the process.

The Freudian psychologist Otto Rank has said that each significant work in the course of an artist's career represents a stage in a continuous process of psychological development. The successful completion of all of these phases results in the liberation of the mature personality.[26] In analogous fashion, the most significant Quitenian sculptures exemplify different stages of a continuous and cumulative process which culminates in a collective self-realization and emancipation.

Certain statues, selected from the preceding chapters and assembled here, provide examples of this progression toward freedom. These drawings are divided into two general categories. The first group of statues represents the sixteenth and seventeenth centuries, a period when European sculpture was dominant in Quito. The second group illustrates important eighteenth-century carvings from the Baroque and Rococo periods, and from Quito's own school

of polychromed wood sculpture. In speaking of sculpture, Bazin equated the realization of freedom with the disengagement of a statue from its architectural niche. The two groups of statues correspond to stages of this development. In the first stage, the statues are still bound to a niche in an altar screen, although they begin to move more freely and expansively within it. In the Quitenian period, the carvings are freed from an architectural setting and begin to act with increasing vitality in three-dimensional space.

The first series comprises images of the Virgin Mary, Saint Francis, San Pedro Alcántara, and Saint Ignatius. The drawing of the statue of the Virgin (a) emphasizes its static quality; the accompanying diagram shows clearly that the major compositional elements are the horizontal and vertical line. In the image of Saint Francis (b), there is a noticeable relaxation from the vertical as a diagonal line is introduced. The carving of San Pedro Alcántara (c) shows the arms held even farther away from the body, while the Saint Ignatius (d) stands with right knee bent and arms spread in a broad, open gesture. Although these individual statues may at first appear to be unrelated, when placed side by side they are seen to form a continuum. Each carving represents a stage in a single collective "gesture" of unfolding as the images appear to awaken and reach forth. When the constricted niche (i) in which the earliest image of the Virgin would have been placed is contrasted with the vastly enlarged niche (j) of Saint Ignatius, this growing dynamism is even more apparent.

Figure 62

Figure 64

The stylistic progressions of European sculpture have brought the image to the very edge of the altar niche. It will be left for Quitenian sculpture of the eighteenth century to take the metaphoric step toward freedom. The carvings of indigenous Baroque and Rococo sculpture will reveal a steady progression toward full spatial freedom. Four examples illustrate this point. The first drawing is of Bernardo Legarda's *Virgen de Quito*, the second of an Immaculate Conception, the third represents an image of Santa Rosa de Lima, and the last illustrates a miniature negro dancer. While the flat planes of the drapery in the carving of the Virgin of Quito (e) still link it compositionally to an architectural setting, a statue of the Immaculate Conception (f) has taken a step toward free movement in space. The mantle which completely encircles the image is explicit in its three dimensionality, the deeply incised folds of the drapery provide a tactile sense of swelling vol-

Figure 63

Text continues on page 146

*Figure 62: European Influences in the
Sixteenth and Seventeenth Centuries*

(a)
Gaspar del Aguila
Virgen con Niño, 1579

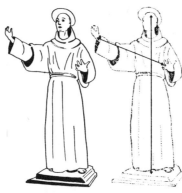

(b)
Circle of Montañes
San Francisco, 1622

(c)
Pedro de Mena
San Pedro Alcántara, 1675

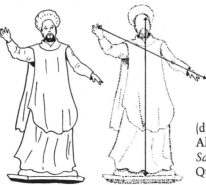

Conclusion

(d)
Alessandro Algardi (?)
San Ignacio de Loyola, 1699
Quitenian copy, 1743

Figure 63: Quitenian Baroque and Rococo Statutes in the Eighteenth Century

(e)
La Virgen de Quito

(f)
Inmaculada Concepcion

(g)
Santa Rosa de Lima

The Seasons of Art

(h)
A Negro Dancer

145

ume. In the image of Santa Rosa (g) the draperies flow in a seemingly casual and informal manner. This signals a turn to the Rococo with its assymetrical line and forms inspired in nature. A comparison of the first Spanish image of the Virgin (i) and Saint Ignatius (j), and the niches to which they are still bound, with the Santa Rosa (k) reveals that the latter, in Bazin's words, has become a self-sufficient organism moving freely in three-dimensional space. This movement toward full freedom culminated in the Rococo when Quitenian sculpture reached its maturity. All of the heightened energies of the Quitenian Rococo are embodied in one miniature carving (h) of a negro dancer who spins in a tight spiral.

Figure 64

Figure 63

The historian Lewis Mumford perceived the city as a container which, by its very structure, held new forms together in close association, intensifying their internal reactions until a single communal coherence emerged.[27] Such a dynamic synthesis—a merger of ethnic and cultural elements—took place in the city of Quito and at the heart of the Quitenian society. During the last quarter of the eighteenth century a greater measure of personal freedom and economic opportunity was enjoyed, and a flowering of all the arts was apparent. Recall that the art historian Bazin equated the full achievement of freedom in space with emancipation and that the psychologist Rank equated liberation with maturity. The full realization of spatial freedom, the color and inventiveness, as well as a sense of joy and release exhibited by Rococo statuary, directly reflected a like realization in Quitenian society. How can this relationship between sculpture and psychology be explained? The discoveries and precepts of modern depth psychology may answer this question.

One of the basic premises of modern depth psychology is that the psyche, be it individual or collective, is divided into two complementary aspects: a "surface" conscious awareness, and underlying it an invisible substratum, the unconscious. These two levels are interdependent and reciprocal. The unconscious is directly related to conscious awareness and determines its most basic processes. These dynamic and autonomous processes cannot be directly observed. However, their presence and nature can be inferred, read back as it were, since they are expressed through the objects of sensory reality, the world of objects by which we are surrounded in everyday life. The existence of this invisible substratum of the unconscious is manifested through objects in time, especially in objects of art.

The creations of artists bear witness to the modalities

Conclusion

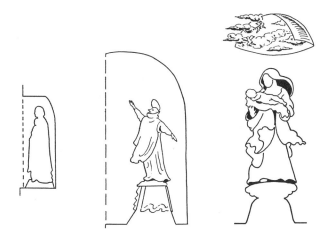

Left to right: (i) Gaspar del Aguila, *Virgen con Niño*, 1579;
(j) *San Ignacio de Loyola*, 1743; (k) Santa Rosa de Lima.

and processes of the unconscious. Because of his special relationship to the unconscious, the artist has access to this dynamic inward dimension. His special talents allow him to participate in its processes and to contact images latent in its depths, to raise them from this submerged plane to a level of manifest reality and give them tangible form. Thus he spontaneously and without deliberation unites the two worlds, the unconscious and the conscious. As a material object, the work of art will bear the imprint of a historic period, of a given cultural climate, as well as of an individual style. However, also revealed will be the nature of the autonomous processes of the unconscious. It has been said that historic tendencies are brought to fruition through the activity of significant individuals; so too are the imperatives of the unconscious.

It is not difficult to analyze an object of art from the standpoint of historic style or cultural context. However, in order to discern the workings of this deeper level of reality, the work of art must be read as a symbol. The unconscious, says Eliade, makes itself known, "speaks," through the agency of symbols. Symbols are "signs" that point to a larger reality beyond the immediately accessible to the unseen world of ideas and of the imagination. The hidden sacramental side of reality is thus disclosed, and it is affirmed as a true and unalterable condition of the real world in which we live.

The Seasons of Art

The fact that eternity is expressed on the plane of manifest reality through periodic regeneration and cyclic renewal is one of the most universal themes in mythology. The most familar cycle of renewal is the progression of the seasons in the course of a single year. In this organic sequence, endlessly repeated, the process of secret germination which occurs in winter, becomes visible in the spring as new growth emerges. Plants flourish throughout the summer until the entire process culminates in autumn, in the fullness and the richness of the harvest. The development of Quitenian society in the colonial period can be perceived in the same organic terms. Seeds, in both a real and metaphoric sense, are brought from Europe and planted in American soil. In this new climate they ripen and eventually reach maturity. The development of Quitenian colonial sculpture is a visual expression of this process. The influences of European art are introduced and gradually assimilated by the mind and spirit of the resident culture. A new "plant," Quitenian colonial art, in time emerges, flowers and reaches maturity in the autumnal phase of the culture. At this culminating moment, in the Rococo, Quitenian colonial sculpture exhibits a unique style and character. Although inextricably linked to its ancestry, it also exists in its own right.

The art historian Bazin equated the full realization of freedom in space with emancipation, and the psychologist Rank associated liberation with maturity. In the context of Quitenian colonial sculpture this moment of maturity and fulfillment is reached in the Rococo. An explicit parallel has been drawn between emancipation and maturity, and between the Rococo phase of Quitenian colonial sculpture and the fall harvest. These are homologous principles; they share a basic structure. As symbols they unite different realities and together they lay bare an irreducible meaning. With self-realization comes freedom.

If a basic structural similarity links autumn and the Rococo, then the preceding phases of Quitenian colonial sculpture are, by extension, "summer" and "spring," and the full round of all the stylistic phases of Quitenian sculpture recapitulate all the seasons of a single year and thus form a complete cycle. The Quitenian colonial period is such a complete cycle, one that lasted almost three hundred years. The seasons of its organic development have been made visible through the works of the Quitenian sculptor. Thus it can be inferred that both culture and nature are bound to cycles of periodic regeneration and that his basic archetypal pattern is expressed through the rhythms of na-

ture as well as through the artifacts of civilization.

Eliade urged the historian to "discover in the cultural style of an age, the existential situation that caused it." Our investigation of Quitenian colonial sculpture has revealed the presence of an underlying pattern of cyclic renewal which determines, in a very basic sense, the forms and expression of art. This pattern of periodic regeneration is the existential cause that we sought. The question asked at the beginning of this chapter is now answered. Quitenian colonial art is linked chronologically and stylistically to both its European and pre-Columbian antecedents. It also responds psychologically to the cultural influences of its own unique ambience and character. However, rising from a much deeper and more imperative level, this underlying force of eternal regeneration is the existential cause of the various phases of Quitenian colonial sculpture and of its entire development.

This pattern of eternal renewal is not applicable solely to Ecuadorian art, but underlies and determines the manifestations of art throughout history. Wherever there is a complete cycle, art will, in a way appropriate to each given cultural context, reveal the secret presence of this dynamic undercurrent of eternal regeneration. While such terms as *Gothic, Baroque,* and *Rococo* may identify historic styles, in a much broader sense they are but local and transient designations—mere descriptions of the phases in this cyclic process. The presence of this existential cause will always be revealed through the creative activity and sovereign spirit of individuals who, like the Quitenian sculptors, establish and preserve contact with these deep sources of Life.

Notes

1. Jorge Juan and Antonio de Ulloa, *A Voyage to South America*, p. 46

2. José Gabriel Navarro, *Guía artística de la ciudad de Quito*, p. 145.

3. Celestino López Martínez, *Desde Jerónimo Hernández hasta Martínez Montañés*, p. 29.

4. Beatrice Gilman Proske, *Juan Martínez Montañés*, p. 106.

5. *Ibid.*, p. 107.

6. María Elena Gómez-Moreno, *Breve historia de la escultura española*, p. 90.

7. José Gabriel Navarro, *Escultura en el Ecuador*, p. 83.

8. Eugenio de Santa Cruz y Espejo, *Primicias de cultura*, p. 83.

9. María Elena Gómez-Moreno, *Escultura del Siglo XVII*, p. 240.

10. *Ibid.*, p. 233.

11. José Rumazo, *Documentos para la historia de la Audiencia de Quito*, Vol. I, p. 63.

12. John Leddy Phelan, *The Kingdom of Quito in the Seventeenth Century.*

13. Juan de Velasco, *Historia del Reino de Quito*, p. 97.

14. John Leddy Phelan, *op. cit.*, p. 63.

15. *Ibid.*, p. 56.

16. *Libros de Cabildo de la ciudad de Quito*, folio 132.

17. Clarence Henry Haring, *The Spanish Empire in America.*

18. *Ibid.*

19. Santiago Sebastián, "La huella italiana en la arquitectura colonial de Colombia y Ecuador," p. 73.

20. Beatrice Gilman Proske, *op. cit.*, p. 11.

21. Clarence Henry Haring, *op. cit.*

22. *Libros de Cabildo de la ciudad de Quito*, folio 158.

151

23. Eugenio de Santa Cruz y Espejo, *op. cit.*, pp. 65–66.

24. Mircea Eliade, *The Two and the One*, p. 192.

25. Germain Bazin, *The History of World Sculpture*, p. 332.

26. Otto Rank, *The Myth of the Birth of the Hero*.

27. Lewis Mumford, *The City in History*, p. 34.

Notes

Bibliography

Alcedo y Herrera, Antonio de. *Diccionario geográfico-histórico de las Indias occidentales o América.* 5 vols. Madrid: B. Canno, 1776.

Angulo Iñíguez, Diego. *Historia del arte hispanoamericano.* 3 vols. Barcelona: Editorial Salvat, 1945.

Aragón, Arcisio. *Popayán.* Popayán: Imprenta del Departamento, 1930.

Barrera, Isaac J. *Quito colonial, siglo XVIII.* Quito: Imprenta Nacional, 1922.

Bazin, Germain. *The History of World Sculpture.* Weerts: Lamplight Publishing Co., 1968.

Bernales Ballesteros, Jorge. "Iconografía de Santa Rosa de Lima," *Homenaje al Prof. Dr. Hernández Díaz.* Sevilla: Facultad de geografía e historia de la Universidad de Sevilla, 1982.

Chapman, Charles E. *A History of Spain.* New York: Free Press, 1965.

Coletti, Juan Domenico, S. J. *Il Gazetierre Americano,* 3 vols. Livorno: Marco Coltellini, 1763.

Concolorcorvo (Calixto Bustamante Carlos Inga). *El lazarillo de ciegos caminantes.* Madrid: Guijón, 1773.

Eliade, Mircea. *The Two and the One.* Chicago: University of Chicago Press, 1979.

———. *Myth and Reality.* New York: Harper and Row, 1963.

Enríquez B., Eliecer. *Quito a través de los siglos.* Quito: Imprenta Municipal, 1969.

Gómez-Moreno, María Elena. *Escultura del siglo XVII.* Vol. 16 of *Ars Hispaniae.* Madrid: Editorial Plus-ultra, 1963.

———. *Breve historia de la escultura española.* Madrid, Misiones de Arte, 1935.

Gómez Moreno, Manuel. *The Golden Age of Spanish Sculpture.* New York: New York Graphic Society, 1946.

Haring, Clarence Henry. *The Spanish Empire in America.* New York: Harcourt, Brace and World, 1963.

Huyghe, René, ed. *Larousse Encyclopedia of Renaissance and Baroque Art.* New York: Prometheus Press, 1964.

Juan, Jorge, and Antonio de Ulloa. *A Voyage to South America.* Baltimore: Penguin Books, 1963.

Jung, Carl. *Man and His Symbols.* New York: Dell Publishing Co., 1964.

Libros de Cabildos de la ciudad de Quito. Quito: Imprenta Municipal, 1969.

López Martínez, Celestino. *Desde Jerónimo Hernández hasta Martínez Montañés.* Sevilla: Rodríguez Giménez y Cia., 1929.

Lozoya, Juan de Contreras, Marquez de. *Historia del arte hispano.* 5 vols. Barcelona: Editorial Salvat, 1945.

Mancini, Franco. *El Belén napolitano.* Madrid: Albaicín/Aldea Editores, 1967.

Mecham, J. Lloyd. *Church and State in Latin America.* Chapel Hill: University of North Carolina Press, 1934.

Mercado, Pedro de, S. J. *Historia de la provincia del Nuevo Reino de Quito y de la Compañía de Jesús* (1620–1701). 5 vols. Bogotá: Editorial Lerner, 1957.

Mesa, José de, and Teresa Gisbert. *Escultura Virreinal en Bolivia.* La Paz: Academia Nacional de Ciencias de Volivia, 1972.

Monroy, Joël. *El convento de la Merced en Quito* (1616–1700). Quito: Editorial Labor, 1932.

Morga, Antonio de. *Sucesos de las islas Filipinas.* Mexico: Balli, 1609.

Mörner, Magnus. *The Expulsion of the Jesuits from Latin America.* New York: Alfred A. Knopf, 1965.

————. *Race Mixture in the History of Latin America.* Boston: Little Brown and Co., 1967.

Mumford, Lewis. *The City in History.* New York: Harcourt, Brace, Jovanovitch, 1968.

Navarro, José Gabriel. *La escultura en el Ecuador.* Madrid: Real Academia de Bellas Artes de San Fernando, 1929.

————. *Guía artística de la cuidad de Quito.* Quito: La Prensa Católica, 1961.

Ortiz de la Tabla Ducasse, Javier. "La población ecuatoriana en la época colonial: cuestiones y cálculos," *Annuario de estudios americanos* 28 (1980).

Pérez Embid, Fiorentino. *San José en el arte.* Madrid: Museo de arte contemporaneo, 1972.

Phelan, John Leddy. *The Kingdom of Quito in the Seventeenth Century.* Madison: University of Wisconsin Press, 1967.

Picón-Salas, Mariano. *A Cultural History of South America.* Translated by Irving A. Leonard. Berkeley: University of California, 1968.

Proske, Beatrice Gilman. *Juan Martínez Montañés, A Sevillian Sculptor.* New York: Hispanic Society of America, 1967.

Rank, Otto. *The Myth of the Birth of the Hero.* New York: Alfred A. Knopf, 1959.

Riva Agüedo, José de la, ed. *Los cronistas de conventos.* Paris: Desclée, 1938.

Roig, Fernando. *Iconografía de los santos*. Barcelona: Ediciones Omega, 1950.

Rumazo, José, ed. *Documentos para la historia de la Audiencia de Quito*. 8 vols. Madrid: Afrodisio Aguado, 1948. Vol. I, Pedro Maldonado.

Sánchez-Cantón, Francisco Javier. *Escultura y pintura del siglo XVIII*. Vol. 17 (first part) of *Ars Hispaniae*. Madrid: Editorial Plus-ultra, 1965.

Santa Cruz y Espejo, Eugenio de. *Escritos*. 3 vols. Quito: Imprenta de la Municipalidad, 1912–13.

Savage, George. *Eighteenth Century Porcelain*. New York: Macmillan Co., 1958.

Schurz, William Lytle. *The Manila Galleon*. New York: E. P. Dutton and Co., 1959.

Sebastián, Santiago. "La huella italiana en la arquitectura colonial de Colombia y Ecuador." *Boletín del centro de investigaciones históricas y estéticas* (November 1971): 45–75.

Stevenson, W. B. *Historical and Descriptive Narrative of Twenty Years' Residence in South America*. 2 vols. London: Longman, Rees, Orme et al., 1829.

Tannenbaum, Frank. *Ten Keys to Latin America*. New York: Random House, 1962.

Tovar, F. Gil, and Carlos Arvelaez. *El arte colonial en Colombia*. Bogotá: Ediciones Sol y Luna, 1968.

Vargas, José María. *El arte ecuatoriano*. Quito: Editorial Santo Domingo, 1967.

———. *Patrimonio artístico ecuatoriano*. Quito: Editorial Santo Domingo, 1967.

Velasco, Juan de. *Historia del Reino de Quito*. Quito: Editorial del Clero, 1789.

Watson, Lyall. *Lifetide*. London: Hodder and Stoughton, 1980.

Von Hagen, Victor Wolfgang. *Ecuador: The Unknown*. New York: Oxford University Press, 1940.

Witaker, Arthur P., ed. *Latin America and the Enlightenment*. Ithaca: Cornell University Press, 1967.

Index